BLACK AMERICA SERIES

KANSAS CITY

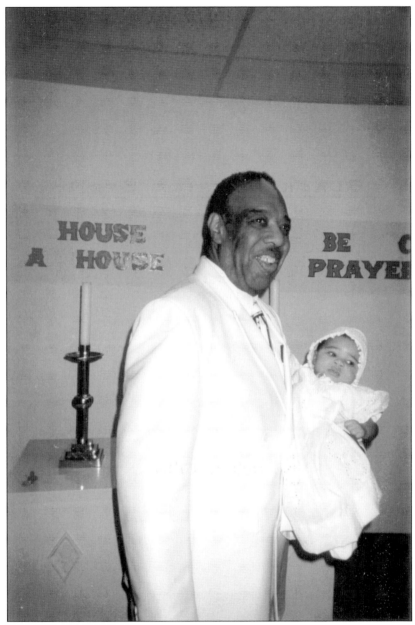

Rev. Earl Abel (September 12, 1930–May 17, 2005) was the founder and pastor of Palestine Missionary Baptist Church at Thirty-fifth Street and Askew Avenue for 46 years. He began his church with 11 members in 1959, but by the time of his death, his church had grown to over 2,000. Reverend Abel graduated from Lincoln High School in 1947. He attended the University of Kansas and earned his doctor of divinity degree from Western Baptist Bible College. Reverend Abel's ministry was particularly devoted to the youth, senior citizens, and community outreach. He is pictured here holding Jasmine Gillis at her blessing ceremony in August 2001. (Author's collection.)

On the cover: The National Urban League dinner at Hotel Ambassador in Kansas City in May 10, 1934, is pictured here. (Courtesy of the Kansas City Urban League Collection, Missouri State Archives.)

BLACK AMERICA SERIES

KANSAS CITY

Delia C. Gillis

ARCADIA
PUBLISHING

Copyright © 2007 by Delia C. Gillis
ISBN 978-0-7385-3448-0

Published by Arcadia Publishing
Charleston SC, Chicago IL, Portsmouth NH, San Francisco CA

Printed in the United States of America

Library of Congress Catalog Card Number: 2005926129

For all general information contact Arcadia Publishing at:
Telephone 843-853-2070
Fax 843-853-0044
E-mail sales@arcadiapublishing.com
For customer service and orders:
Toll-Free 1-888-313-2665

Visit us on the Internet at www.arcadiapublishing.com

*This book is dedicated to my children, Colin Andrew
Cook, Robert Eugene Gillis Jr., and Jasmine Anais Gillis.
I love you all dearly. And to Erica Michelle Maria Green,
Kansas City's precious doe. This book pays tribute to a
community that refused to allow a little girl's senseless
death to languish in obscurity.*

CONTENTS

ACKNOWLEDGMENTS

Kansas City is the result of much collaboration. I extend my sincerest gratitude to Donna Stewart, managing editor at the *Kansas City Call*, who allowed me access to the photograph archives. The success of this project rests with Donna as well as Bill and Annette Curtis, who not only lent photographs from their personal collection, but Bill spent hours scanning photographs and providing historical data for the captions.

Several community leaders provided photographs and generously lent their knowledge to the project, including Albert O. Bly, Sonny Gibson, Chuck Haddix, Mamie Hughes, Pat Jordan, Larry Lester, Irene Marcus, Joe Mattox, Wilhelmina Stewart, and the Honorable Sharon Sanders Brooks. Thanks also go to Lynn Boyer, Dr. Carrie Dunson, Ida Hughes, Sandra Irle, Crystal Lumpkins, Candice Maupins, Dr. DeAnna Reese, June Hollowell Ross, Geri Sanders, Dr. Irene Starr, and Dr. Dorether Welch. I extend a very warm thank-you to my sister Kim Crutchfield Howard and my husband, Robert Gillis, who delivered photographs to me during the 11th hour of the project.

Thanks to Laura Jolly at the Missouri State Archives, Ray Doswell and the Negro Leagues Baseball Museum, Bill Livingston and Pam Ross at the Black Archives of Mid-America, Denise Morrison and the Kansas City Museum at Union Station, Charles Machon and the Missouri National Guard Museum, Emily Rolfs and the State Historical Society of Missouri, Adrie Taylor and the American Jazz Museum, Pauline Testerman and the Truman Library, Dave Whalen formerly of the Jazz District Redevelopment Corporation, John Viessman and the Missouri State Museum, and Barbara Moore at the Library of Congress.

Funding from the College of Arts and Sciences Research Awards, the Faculty Senate Professional Enhancement Grant, and the University of Central Missouri Research Council Grant provided funding to support the project. Thanks to my department chairman, Dr. John Sheets, for leading by example and creating an environment where scholarly endeavors are supported. Many thanks to my colleagues at Central: Dr. David Aaberg, Amber Clifford, Sean Cripe, Holly Davenport, Demelza D'souza, Terry Fayle, Freda Harrington, Ruth Hirner, Terry McNeely, Judith Siminoe, Dr. Jon Taylor, and Dr. Jeff Yelton. Thanks to Elizabeth Beachy, acquisitions editor at Arcadia, for believing in the project. Thanks to Arcadia authors Lisa Irle and Dr. Ron Stephens for providing excellent examples in their books and for their encouragement. All errors whether of fact or interpretation are mine alone.

To my publisher at Arcadia, John Pearson, I have been deeply humbled by your patience with me and your unwavering support of this project. Thank you.

INTRODUCTION

My intellectual interest in preparing this book stemmed from teaching local history for more than a decade where I have illuminated salient issues in American history in general and African American history in particular. Yet Kansas City remains a destination in song and not in the prevailing scholarly literature. While scholars Janet Bruce, Frank Driggs, and Chuck Haddix have documented Kansas City's importance to baseball and jazz, there is no scholarly work that addresses the history of the African American community save the recent contribution of Charles Coulter. *Kansas City* adds to the literature by laying a visual foundation for future studies focusing on political, social, and cultural history as well as community development and civil rights.

Over the past 16 years, I have been awed in the ways in which Kansas City's African American community has been on the cusp of virtually every national issue whether slavery, abolition, women's clubs, civil rights, education, cultural innovations, or business entrepreneurship. Accomplishments in Kansas City's African American community rank comparably with even larger cities like Atlanta, Chicago, Dallas, New York, and Washington, D.C. Thus, the context of these selected images rests on their local importance as well as their connection to national or even international issues and movements.

When I first began collecting photographs for *Kansas City*, I believed that it would be a difficult task to locate 200 or more visual images. Where would I find so many photographs in a relatively short period of time? Instead, the challenge became how to best capture a history with only 230 images. At the national level, it was a delight and a confirmation of Kansas City's status to find relevant photographs at the Library of Congress, the National Archives, and especially the Schomburg Center of Black Culture. State and local archives supplemented my work as well as private collections. Hopefully this work will serve as an impetus for families, civic organizations, schools, and churches to preserve and document their respective historical narratives.

As I began to discover personal collections that proved to be useful in producing a social history, it became challenging to decide which photographs to include and which ones to omit from the book. By embracing a methodology that focused on community, I was able to include a wide array of images. I was aided in the decision process by consulting a number of books and articles, including *Your Kansas City & Mine* and *Kansas City: Mecca of the New Negro*. Yet this organization represents only one model of Kansas City's illustrious history. It is my greatest hope that the academic world and the community at large will embrace the book as a launching point for further study of African American Kansas City, especially its women's club and its civil rights activities, as well as its business, professional, and laboring classes

Kansas City encompasses six chapters that explore the legacy of the African American community from the early 1800s until 2006. It is a book of mini biographies, family histories, and colorful

personalities. Within these pages, you will meet slaves, slave owner, free blacks, educators, the clergy, musicians, journalists, athletes, businesspeople, soldiers, elected officials, public servants, and even a millionaire. From the famous to the infamous, from leaders to everyday people, this visual history provides a record of struggle and achievement of continuity and change. *Kansas City* also introduces the reader to a host of cultural and social institutions including the Historic Eighteenth and Vine District, the Paseo YMCA, the *Kansas City Call* newspaper, Wheatley-Provident Hospital, the Niles Home for Children, and Lincoln High School. The book is further enhanced with street scenes, parades, dinners, and celebrations. Furthermore, *Kansas City* pays tribute to African American photographers like William Fambrough and Elijah Washington. With the African American community poised for a rebirth in the millennium, this work seeks to aid existing and proposed preservation projects. Over the past decade, the city has witnessed massive redevelopment efforts, and *Kansas City* brings these projects to the scholarly community and the general public.

While this book focuses on 20th-century history, chapter 1 provides an overview of African Americans who built the region in slavery and in freedom. It examines the western folklore and the multiple meanings of freedom uncovered by black western pioneers. Chapter 1 documents some of the most significant aspects of African American life during the 1800s in the Kansas City region. In particular, the acquisition of the Susan "Suse" Younger portrait was important given the paucity of sources on women. Chapter 2 combines over 50 photographs that highlight leaders, institutions, and organizations. For African Americans at the dawn of the 20th century, racial uplift was the most paramount concern given the ravages of segregation. The Kansas City Urban League Collection at the Missouri State Archives proved pivotal in providing images that underscored African Americans and their social welfare concerns. Researchers should continue to mine this collection for the myriad of scholarly treasures it holds.

In chapter 3, I consider the two most nationally recognized elements of Kansas City's African American community, jazz and baseball. Kansas City is a destination documented in historical music, and these photographs provide a visual interpretation. Chapters 4 and 5 explore the transformation of Kansas City during its civil rights years. The chapters explore the struggle for civil rights in education, public accommodations, and equal access in a residentially divided city. They also explore the dynamic leadership of Bruce R. Watkins, Lucile Bluford, and John "Buck" O'Neil. Black Kansas Citians were at the forefront of political activity and grassroots movements, making it home to Freedom Inc., the oldest African American political organization in the country.

Kansas City is an original contribution to the history of the Kansas City African American community and its environs. Ultimately this book documents the history and culture of Kansas City's rich and vibrant world immortalized in song. A portion of that rich history is now preserved for posterity through these images.

One

IN SLAVERY AND FREEDOM

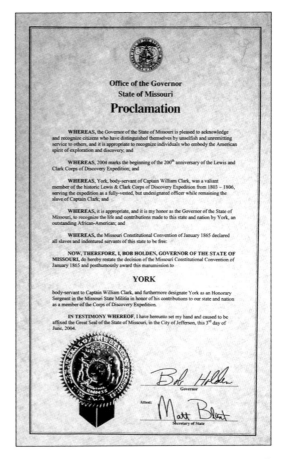

York was the slave that accompanied Meriwether Lewis, William Clark, Sacagawea, and the dog Seaman on the exploration of the Louisiana Purchase. While York's role was essential in the success of the venture, Clark never granted York his freedom. (Courtesy of the Bruce R. Watkins Cultural Heritage Center and the Missouri Civil Rights Museum.)

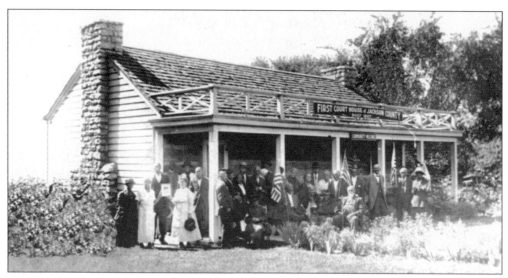

The first courthouse of Jackson County and the only courthouse between St. Charles, Missouri, and the Pacific Ocean was constructed of squared logs in 1827 by Sam Shepard, a slave. His careful workmanship can still be seen in the walls of the original courthouse that is now open for tours. This photograph also captures the Ex-Slave Association founded in the early 1920s by former slaves in the area. The founding meeting was on Watermelon Hill, the segregated area set aside for African Americans in Kansas City's Swope Park. Their goals were to preserve the memory of slavery and petition the Missouri legislature for payment of wages that they did not receive while working as slaves under Missouri slavery laws. (Courtesy of William and Annette Curtis.)

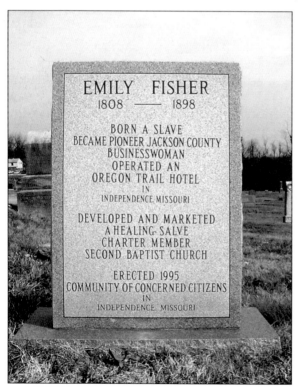

Emily Fisher was a slave owned by Adam Fisher, a prominent resident of eastern Jackson County and reputedly her father. Emily earned her freedom in the 1850s, and Adam placed her in charge of a hotel in Independence serving those traveling west on the three trails. She later made her living marketing a healing ointment. A monument in Woodlawn Cemetery in Independence and historical markers all along the Santa Fe Trail honor this highly successful pioneer African American businesswoman. (Courtesy of William and Annette Curtis.)

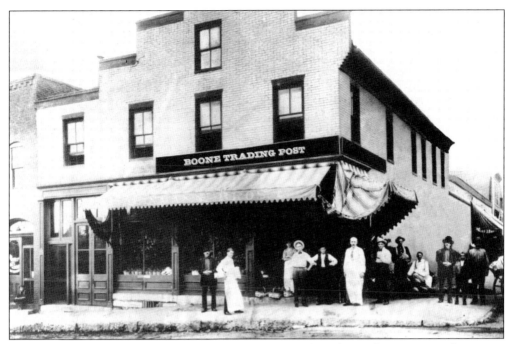

The Boone Trading Post (now Kelley's Tavern) was located on the northwest corner of Westport Road and Penn Street. This is one of the oldest business buildings in Kansas City. As early as the 1840s, wagon trains stopped to purchase supplies from Boone's Trading Post. Slaves were also auctioned here. (Courtesy of William and Annette Curtis.)

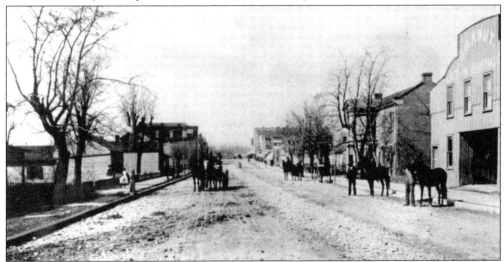

Westport was a town built along the Santa Fe Trail that was later annexed by Kansas City. This view of Westport is looking southwest along Westport Road (the old Santa Fe Trail). The John Harris pre–Civil War mansion is the second building from the right. It is now just southwest of Main Street and Westport Road. The Battle of Westport was fought just south of this area in October 1864 and was a major Confederate defeat. The buildings at the far center of the photograph are the business center of Westport where Penn Street crosses. Westport had a large African American population and its school for black children was the Penn School, founded in 1866. It was located on Penn Street two blocks south of Westport Road. (Courtesy of William and Annette Curtis.)

COMMISSIONER'S SALE OF
SLAVES!

By virtue of an order of the Probate and Common Pleas Court of Jackson County, made at the November term thereof, A. D. 1855, the undersigned Commissioner, will offer for sale, at public auction, to the highest and best bidder, at the Court House door in the city of Independence, on the 1st day of January next, the following described slaves, belonging to the heirs of Mrs. Ann Courtney, deceased, for the purpose of partition amongst said heirs, to-wit:

One woman, named, Mary, aged 30 years;
One girl, named Louann, " 2 "
One girl, named Elizabeth Ann, aged 3 months;
One man, named John, aged 29 years.

Terms.---A credit of six months, purchasers giving bond with appproved security. **GEO. W. BUCHANAN,**

Slave posters are valuable sources of information in Jackson County since there are no official county slave records. They tell the status of slaves as property and provide the names of people who are not listed in any other historical record. (Courtesy of William and Annette Curtis.)

This sketch of the infamous slave pen was made from descriptions by former slaves. A slave pen held the slaves while they waited to be auctioned to the highest bidder. (Courtesy of William and Annette Curtis.)

This particular slave poster emphasizes the role of gender as the slave owner is a woman. All of the slaves advertised to be auctioned were women and children. (Courtesy of William and Annette Curtis.)

VALUABLE SLAVES FOR
SALE.

By virtue of an order of the Jackson county Court, made at the May term thereof, A. D. 1853, the undersigned will offer for sale at public auction to the highest bidder, at the Court House door in the City of Independence, on the first Monday of June next, between the hours of 9 o'clock in the forenoon and 5 o'clock in the afternoon of that day, the following described slaves, belonging to the Estate of Isabella Chiles, deceased, to wit:

One woman named Harriet, aged 32 years.
" girl " Ellen, " 17 "
" " " Milla, " 13 "
" boy " Dick, " 9 "
" girl " Jinny, " 6 "
" boy " John, " 3 "

The title to said slaves is indisputable. Terms: Cash. George W. Buchanan,
May 7th, 1853. Administrator.

Samuel and Maria Gregg were Jackson County slave owners. (Courtesy of William and Annette Curtis.)

Ellen Gregg was a slave of Samuel and Maria Gregg. (Courtesy of William and Annette Curtis.)

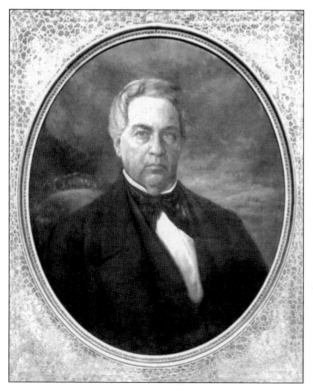

Jabez Smith was the largest slave owner in Jackson County. He owned several hundred slaves, making him one of the major slave owners in the country. His home was located at the current site of William Chrisman High School. (Courtesy of William and Annette Curtis.)

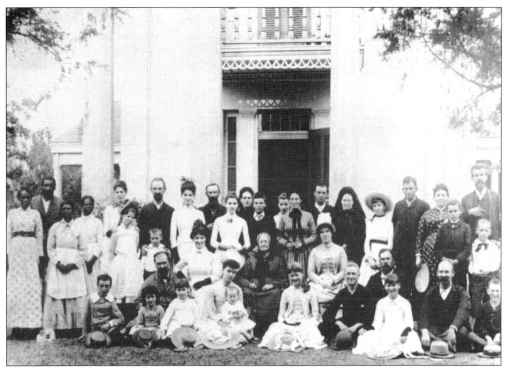

This John Wilson House photograph includes family members and slaves. (Courtesy of William and Annette Curtis.)

This is the home of Col. George S. Park, the leading abolitionist in the Kansas City area. He helped many slaves cross the Missouri River to freedom at Quindaro, Kansas, traveling north to safety and ultimately freedom. Today the home is a part of the Park University campus. (Courtesy of William and Annette Curtis)

This is a rare tintype photograph showing an African American soldier from Missouri in uniform. (Courtesy of William and Annette Curtis.)

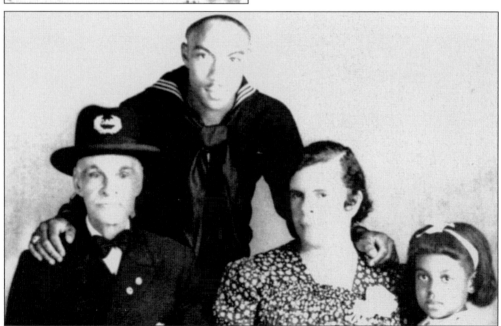

George W. Johnson was the last veteran survivor of the Civil War in Kansas City. He was born free on July 4, 1847. In 1863, he joined Company D, 1st Regiment U.S. Colored Volunteers Infantry. He died at the home of his daughter Priscilla Lee Jones at 2307 Michigan Avenue on August 1, 1945. He was buried in Highland Cemetery. (Courtesy of William and Annette Curtis.)

Susan "Suse" Younger, pictured here around 1855, was a slave and then a servant of Henry and Bursheba Younger. It is widely believed that she saved the life of their son Cole Younger of the infamous Jesse James Gang. (Courtesy of the B. J. George Collection, State Historical Society of Missouri.)

Handsome Joe Herndon was an African American member of the Jesse James Gang. Herndon came from a prominent African American family from Springfield, Missouri, who later moved to Kansas City. (Courtesy of William and Annette Curtis.)

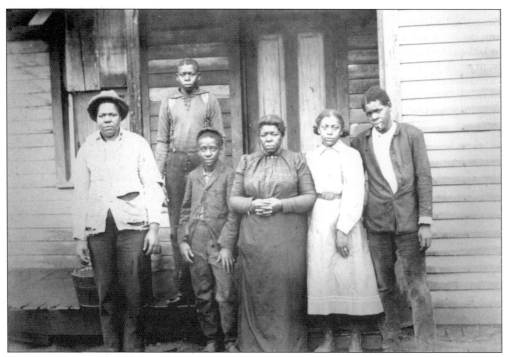

This is an 1890 photograph of an African American family that helped the Trumans on their Grandview farm (Courtesy of the Harry S. Truman Library and Museum.)

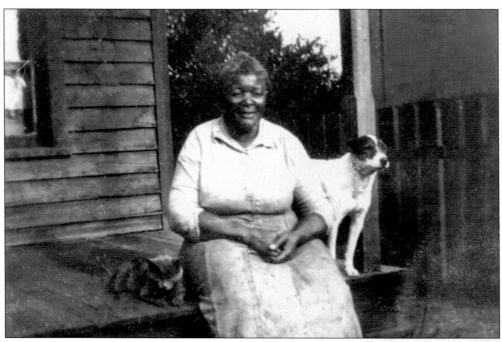

Caroline Simpson Hunter was born a slave. She was the longtime cook for John and Martha Truman, the parents of future president Harry S. Truman, his brother Vivian, and sister Mary Jane. (Courtesy of William and Annette Curtis.)

Granville Tucker was the son of Hartwell and Betsy Tucker, and he served as marshal in Jackson County. This photograph dates from about 1890. The Tucker family had been slaves of Jabez Smith, the largest slave owner in Jackson County. (Courtesy of William and Annette Curtis.)

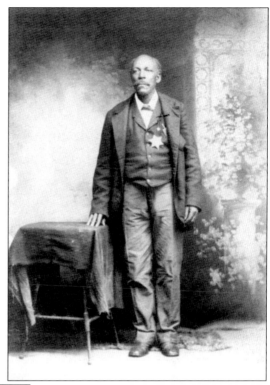

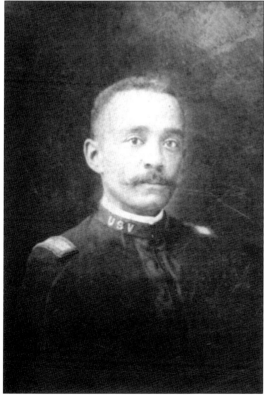

Buffalo soldier Harry Roger was born in February 1871 in Independence, the son of Argyle and Oletha Rogers. He served in the Indian Wars in Arizona in the late 1880s into the 1890s. Many buffalo soldiers of the 9th and 10th U.S. Volunteer Cavalry came from the Kansas City area. (Courtesy of William and Annette Curtis.)

The Young School operated from 1874 until 1934. It was named after the famous and wealthy Hiram Young whose wagon and ox yoke factory supplied many of the pioneers and traders using the Santa Fe, Oregon, and California Trails going west. Young was born a slave. He purchased his freedom as well as his wife's freedom with money earned from his blacksmithing skills. He became one of the richest men in Jackson County and effectively set a number of slaves free after teaching them a trade. (Courtesy of William and Annette Curtis.)

By 1900, Africans Americans in the United States in general, and Kansas City in particular, had made phenomenal progress in building the nation and securing their freedom. Dr. William H. Crogman wrote on that subject in *Progress of a Race*. His findings would resonate throughout the 20th century in Kansas City not only from his book but with the social activism of his daughter Ada Crogman Franklin. (Courtesy of William and Annette Curtis.)

Two

"Lifting as We Climb"

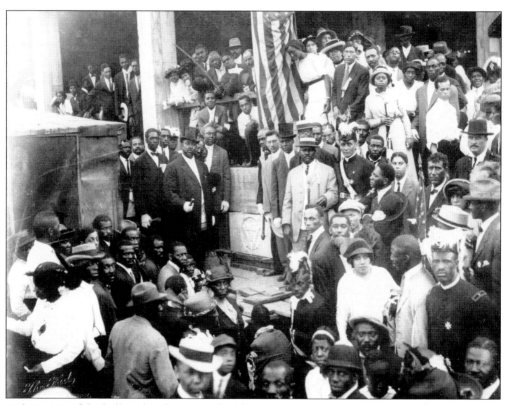

Perhaps one of the hallmarks of progress for African American Kansas Citians was the new YMCA. This photograph captures the celebration when the cornerstone was laid on the Paseo Boulevard just south of Eighteenth Street. H. O. Cook, James Crews, Edward Ross, Aaron Starnes, G. J. Starnes, and W. W. Yates led the YMCA movement in the African American community. (Courtesy of the Schomburg Center for Research in Black Culture, New York Public Library.)

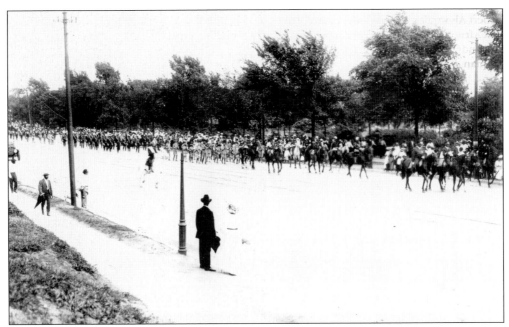

African Americans had much to celebrate in this YMCA parade along the Paseo Boulevard. Philanthropist Julius Rosenwald gave $25,000 to build the YMCA but only after the community had raised $75,000. Kansas City's white YMCA provided $50,000, and the remaining $25,000 was raised by Dr. John Perry, Chester A. Franklin, Felix Payne, and T. B. Watkins, among many others. (Courtesy of the Schomburg Center for Research in Black Culture, New York Public Library.)

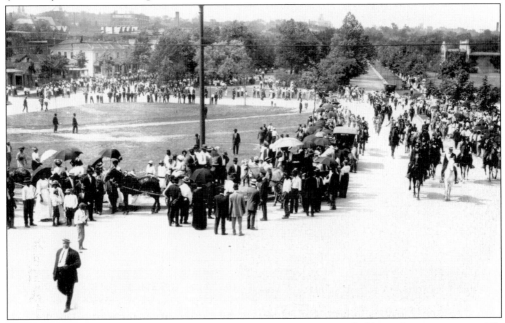

The YMCA parade also symbolized the centrality the organization held in African American life in the early 20th century. The YMCA provided shelter, meeting space, a cafeteria, and a myriad of recreational activities. (Courtesy of the Schomburg Center for Research in Black Culture, New York Public Library.)

Robert Alexander was one of Kansas City's first African American policemen. Besides Alexander, William F. Davis, Lafayette Tillman, Cornelius Carter, John W. Hughes, and J. J. Mattjoy served and protected the African American community. (Courtesy of the Kansas City Museum at Union Station.)

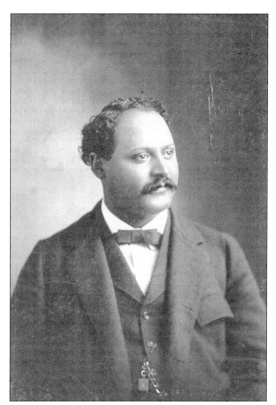

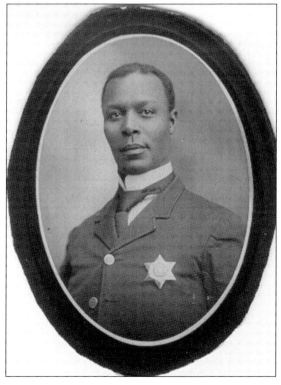

Lafayette Tillman was the second African American policeman in Kansas City. A graduate of Oberlin College, Tillman was respected in both the white and African American communities. (Courtesy of the Kansas City Museum at Union Station.)

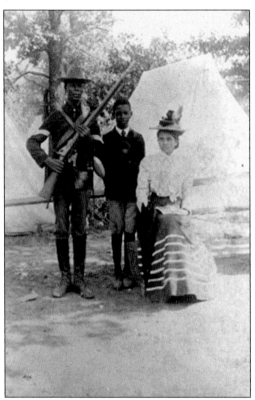

In a rare portrait, Lafayette Tillman is shown with his wife, the former Amy Dods of St. Louis, and an unidentified family friend. The Tillmans had two daughters, Portia and June. Their son, Dr. Lon M. Tillman, was a physician at Wheatley-Provident Hospital in Kansas City. (Courtesy of the Kansas City Museum at Union Station.)

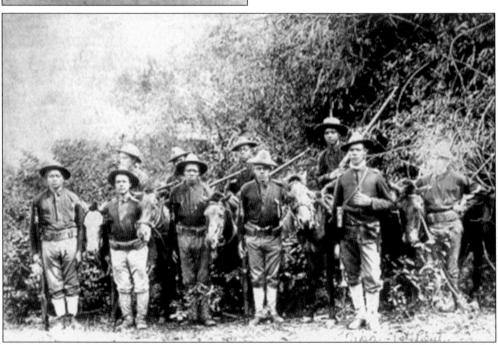

Tillman entered military service in 1898 and quickly rose through the ranks, becoming a first lieutenant of the 49th Infantry Regiment. The unit saw action in the Philippines during the Spanish-American War. (Courtesy of the Kansas City Museum at Union Station.)

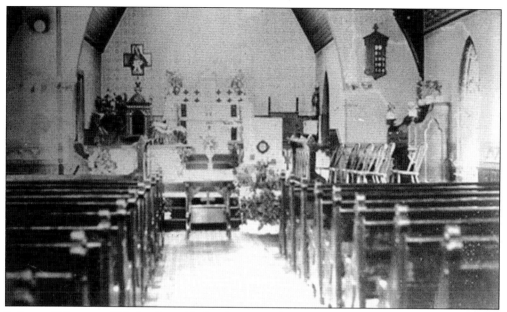

Lafayette Tillman and his family resided at Seventeenth Street and Lydia Avenue and were lifelong members of St. Augustine's Episcopal Church. When Tillman returned from the Spanish-American War, he brought with him candlesticks from a church in Luzon on the Philippine Islands destroyed by Adm. George Dewey. Tillman donated the candlesticks to St. Augustine's where they were blessed by the priest during a special service on Candle Mass day. (Courtesy of the Kansas City Museum at Union Station.)

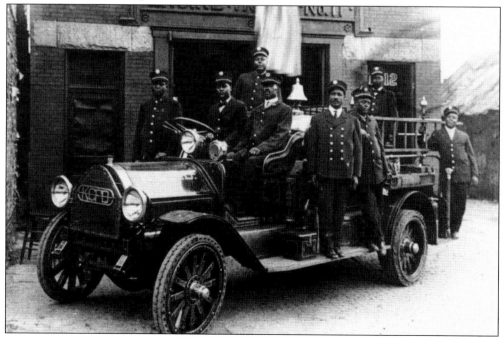

Fire Station Company No. 11 was established in 1890 with Ed Baker as its first captain. At the time, it was the only African American fire company in the state of Missouri. (Courtesy of the Black Archives of Mid-America.)

This is the home of William Tecumseh Vernon. An African Methodist Episcopal bishop, Vernon was president of Western University and served as register of the United States Treasury from 1906 to 1911. (Courtesy of William and Annette Curtis.)

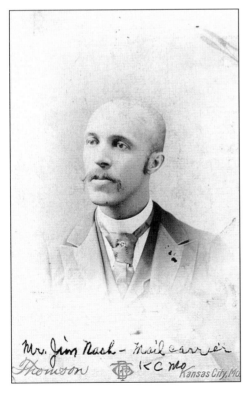

Mr. Jim Nash - Mail carrier
Thomson KC Mo
 Kansas City, Mo

African American men found public employment as police officers, firemen, and postal workers. The portrait shows mailman Jim Nash. (Courtesy of the Kansas City Museum at Union Station.)

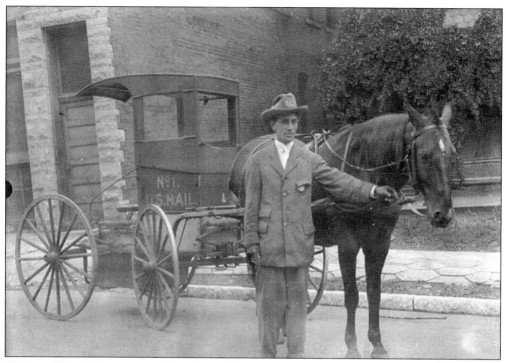

Mailman Harry Johnson poses here for a photograph. (Courtesy of the Kansas City Museum at Union Station.)

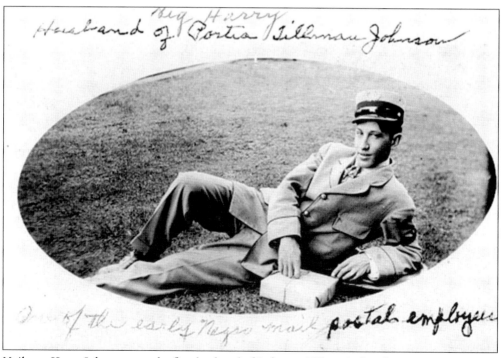

Husband of Big Harry Portia Tillman Johnson

...of the early Negro mail postal employee

Mailman Harry Johnson was the first husband of Lafayette Tillman's daughter Portia, who was a schoolteacher. (Courtesy of the Kansas City Museum at Union Station.)

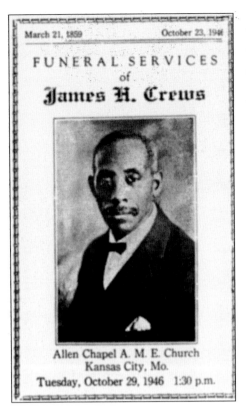

March 21, 1859 October 23, 1946

FUNERAL SERVICES
of
James H. Crews

Allen Chapel A. M. E. Church
Kansas City, Mo.
Tuesday, October 29, 1946 1:30 p.m.

James Crews was the first black postman in Kansas City and was an active supporter of the YMCA. He was buried in Highland Cemetery. A post office was named after him just south of Truman Road on the west side of Prospect Avenue. His brother was Nelson Crews, a Republican, YMCA supporter, and civil rights activist. (Courtesy of William and Annette Curtis.)

Dr. Thomas C. Unthank was the first African American physician to practice medicine in Kansas City. He established the first public hospital for African Americans in Kansas City called General Hospital No. 2. Unthank placed a special emphasis on the training of African American medical professionals. After his death in December 1932, a community committee headed by Dr. J. E. Perry and Minnie Crosthwaite raised monies to dedicate a plaque in his honor at the hospital. (Courtesy of William and Annette Curtis.)

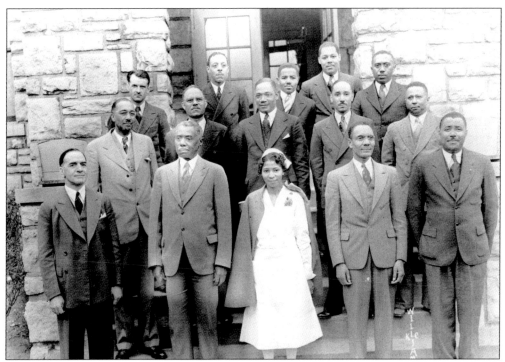

Dr. J. E. Perry worked diligently with Dr. Thomas Unthank. Perry is second from left in the front row with the Wheatley-Provident staff. (Courtesy of the Black Archives of Mid-America.)

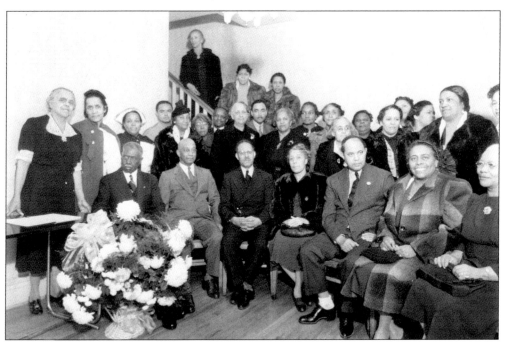

Minnie Crosthwaite (first from the left, standing) and Dr. J. E. Perry (seated behind the floral arrangement) join supporters of the Wheatley Nurses Association. (Courtesy of the Black Archives of Mid-America.)

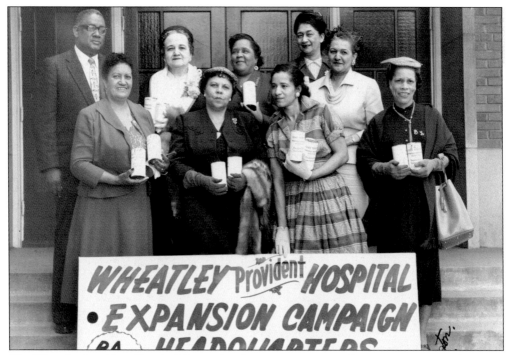

The Wheatley-Provident Hospital Expansion Campaign was one of many activities used to raise money for the hospital. Minnie Crosthwaite, in particular, was noted for her fund-raising abilities, including the annual fashion show. (Courtesy of the Elijah Washington Collection, Black Archives of Mid-America.)

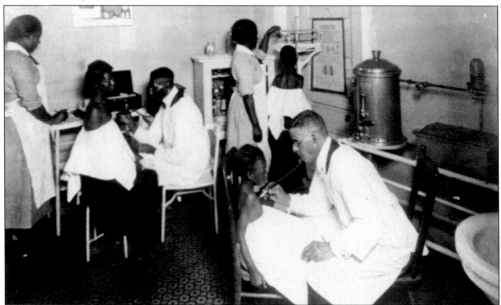

Tuberculosis took a big toll in the Kansas City black community. Wheatley-Provident Hospital established the first tuberculosis diagnostic clinic for African Americans. A Dr. Scott is on the right, Dr. William Anderson is on the left, and nurse Edith Robinson is at the scales. (Courtesy of William and Annette Curtis.)

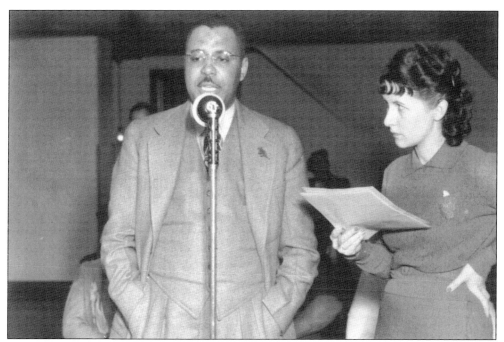

Dr. E. B. Perry was the great-grandson of abolitionist Frederick Douglass and the son of John and Fredericka Douglass Perry. He later moved his practice to Houston, Texas, where his father joined him in retirement. (Courtesy of the Kansas City Urban League Collection, Missouri State Archives.)

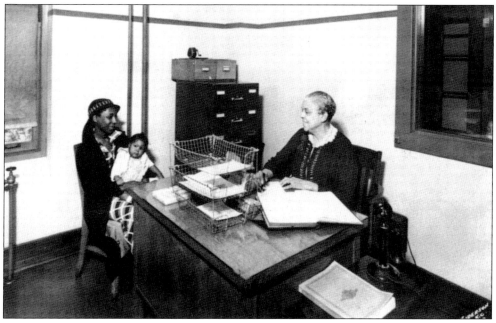

Minnie Crosthwaite is enrolling a child in the Wheatley clinic. Crosthwaite was the first African American social worker in Kansas City. She almost single-handedly managed Wheatley-Provident Hospital, including handling most of the office work. Wheatley-Provident Hospital might not have survived without her hard work and dedication. (Courtesy of William and Annette Curtis.)

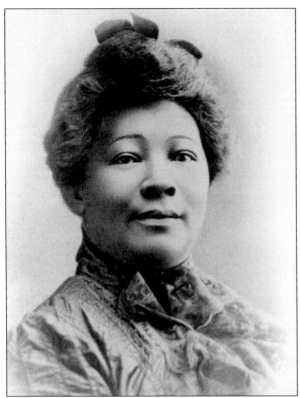

Josephine Silone Yates was a native of Rhode Island and taught at Lincoln University in Jefferson City. She was the third national president of the National Association of Colored Women. Yates was the wife of educator and YMCA supporter W. W. Yates. (Courtesy of the Library of Congress.)

Anna Jones, Ida Beck, and Josephine Silone Yates spearheaded the YWCA's development. By 1920, the Paseo YWCA was established with widespread community support. Mabel Bickford served as the first executive secretary. (Courtesy of William and Annette Curtis.)

Chester A. Franklin founded the *Kansas City Call* newspaper in 1919 with the support of his mother, Clara Belle Williams Franklin. At the time of its original publication, there had been 19 previously unsuccessful African American newspapers in the city. The *Kansas City Call* remains in publication today. (Courtesy of the Black Archives of Mid-America.)

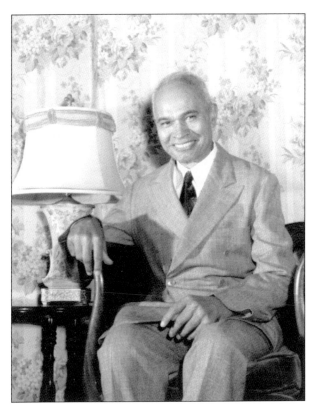

Ada Crogman Franklin was the daughter of Atlanta University president, Dr. William H. Crogman. She wrote a nationally acclaimed play entitled *Milestones of a Race*. The Franklins were married in 1925 and worked together for the benefit of the African American community. Their letters are testimony to their intellectual love affair and commitment to African American uplift. (Courtesy of the Black Archives of Mid-America.)

Pictured here is Chester A. Franklin's *Kansas City Call* office. (Courtesy of William and Annette Curtis.)

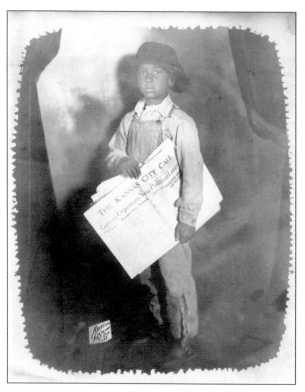

The *Kansas City Call* was a family and community endeavor. A coveted position for the youth of the city was to carry the newspaper, as evidenced by this paperboy. (Courtesy of the Black Archives of Mid-America.)

This photograph shows an unidentified African American World War I soldier. (Courtesy of the Missouri Military State Archives.)

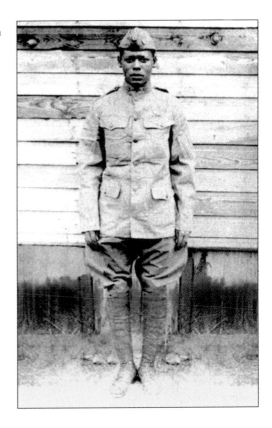

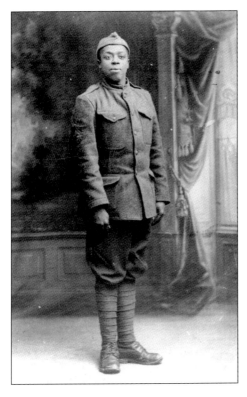

During World War I, over 300 African American soldiers were trained at nearby Western University. (Courtesy of the Irene Marcus Collection, Missouri State Museum.)

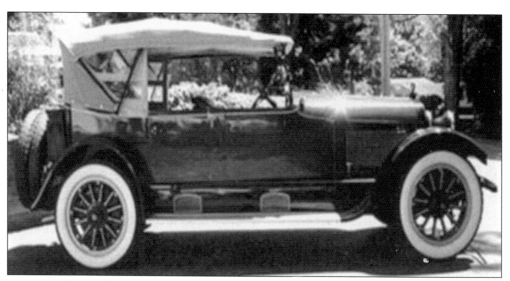

| SURNAME | FIRST NAME | MIDDLE NAME | CARD NO. |
| ROBERTS | Homer | Burnette | 7765 |

ADDRESS AT TIME OF ENLISTMENT
2435 Montgall St., Kansas City, Mo. SERIAL NO. 1,974,378

PRESENT ADDRESS
1516 E. 19th St. Kansas City. CLAIM NO. 36784

DATE OF ENLISTMENT Dec 12/17 DATE OF DISCHARGE Mar 31/18 ACTUAL TIME 14-28 ALL'D 15Mo.

DATE REPORT ACTIVE DUTY NAVY Apr 1/18 DATE RELIEVED ACTIVE DUTY NAVY Mar 10/19 ACTIVE TIME NAVY ALL'D NAVY

AMOUNT ALLOWED $ 150.00 VOUCHER NO. 49412 DATE DATE SENT TO AUDITOR JUL 11 1922

DATE RETURNED FROM AUD. JUL 12 1922 WARRANT NO. 50112 DATE

AMOUNT OF WARRANT $150.00 DATE WARRANT MAILED JUL 12 1922

CLAIM PENDING ADDITIONAL DATA

PROOF OF RESIDENCE
DATA OR DISCHARGE. PROOF OF SERVICE VERIFIED BY DISCHARGE.

CHARACTER OF SERVICE JUN 13 1922 CHARACTER OF DISCHARGE

DOUBTFUL REQUESTED. MISCELLANEOUS

USED WITH FORM 2 ONLY
SURNAME FIRST NAME MIDDLE NAME

BENEFICIARY
ADDRESS OF BENEFICIARY

RELATION TO DECEASED

DATE OF DEATH PLACE CAUSE

REFERENCE

REFERENCE

FORM 3 SUPPLEMENTAL EVIDENCE

EXAMINED BY DUNN. DATE JUL 6 1922

TO COMMISSION RECOMMENDING APPROVAL DISAPPROVAL JUL 11 1922 DATE

APPROVED BY COMMISSION JUL 11 1922

DISAPPROVED BY COMMISSION

REASON DISAPPROVED DATE CLAIMANT NOTIFIED

SENT TO APPEAL BOARD RETURNED BY APPEAL BOARD

DECISION OF APPEAL BOARD CLAIMANT NOTIFIED OF DECISION

WRITE ADDITIONAL INFORMATION ON REVERSE SIDE. Library Bureau 63-10916

Homer Roberts was the first African American officer in the Signal Corps during World War I. After the war, he was the first African American to open an automobile dealership in the country in the heart of Kansas City's African American business district at Nineteenth and Vine Streets. (Courtesy of the Missouri State Archives.)

Roberts sold cars like this 1922 automobile to notable African Americans. He also pioneered innovative advertising techniques. (Courtesy of Geraldlyn "Geri" Sanders.)

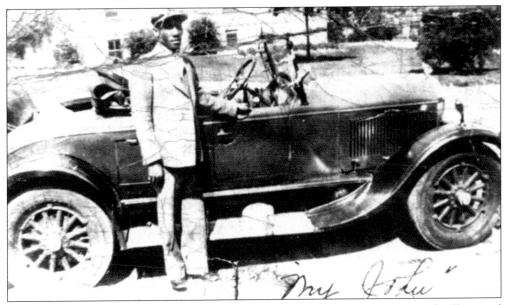

In this photograph, James Henry White poses next to an automobile. (Courtesy of William and Annette Curtis.)

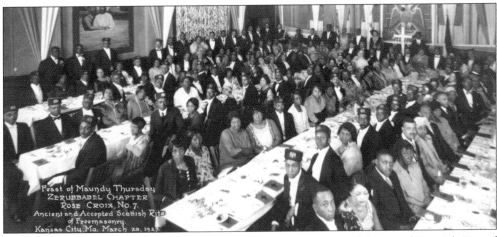

This photograph from March 28, 1929, showcases the Ancient and Accepted Scottish Rite of Freemansonry, Zerubbabel chapter, Rose Croix No. 7, celebrating the Feast of Maundy Thursday. (Courtesy of Chris Wilborn and Associates.)

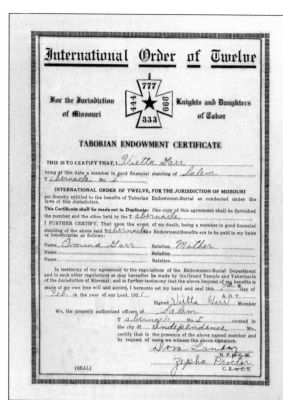

The Knights and Daughters of Tabor were established at the St. Paul African Methodist Episcopal Church in Independence by Rev. Moses Dickson of St. Louis. It became a national organization of great importance until its demise during the Great Depression. Since white companies would not insure African Americans, organizations like the Knights of Tabor provided life insurance and medical insurance. They also operated an orphanage and nursing home in Kansas City. Members gave weekly dues to pay for these services and careful records were kept. This photograph is of the membership certificate of Vietta Garr, an employee and family confidante of Pres. Harry S. Truman and his family. (Courtesy of William and Annette Curtis.)

Sarah Rector was Kansas City's first black woman millionaire. She received her wealth as a young girl in Oklahoma from her Creek Indian landholdings when oil was found on the property. Her mansion still stands at Twelfth Street and Euclid Avenue. (Courtesy of Geraldlyn "Geri" Sanders.)

This classroom photograph was taken at St. Monica's Church and school. (Courtesy of William and Annette Curtis.)

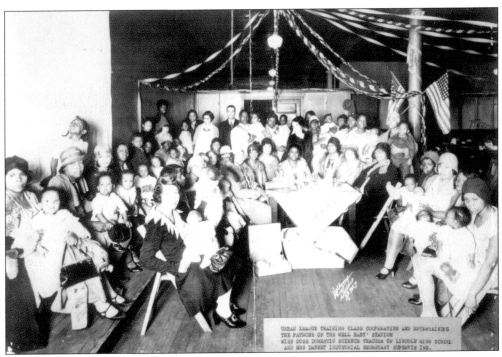

This photograph shows a Kansas City Urban League well baby clinic in 1920. (Courtesy of the Kansas City Urban League Collection, Missouri State Archives.)

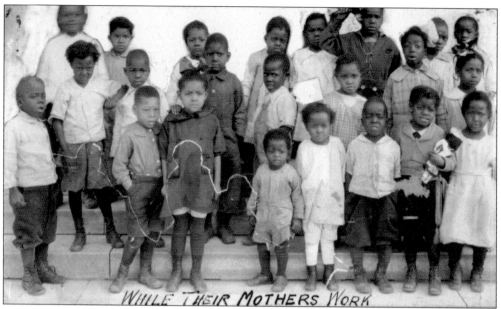

Besides medical care, the Kansas City Urban League also operated a day nursery to assist working families. (Courtesy of the Kansas City Urban League Collection, Missouri State Archives.)

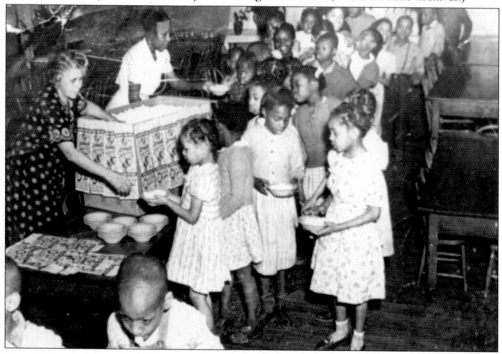

Samuel Eason saw small children wandering the streets of Kansas City, and he was so concerned about their welfare that he turned his own house into a home for such children. Eason garnered support, including money and supplies, and the home was incorporated in 1904. Eason died on August 16, 1913. After Eason's death, the management of the home was assumed by the Colored Industrial Charity Association. In the 1920s, the wealthy Niles family donated enough money to construct a substantial building that became the Niles Home for Children.

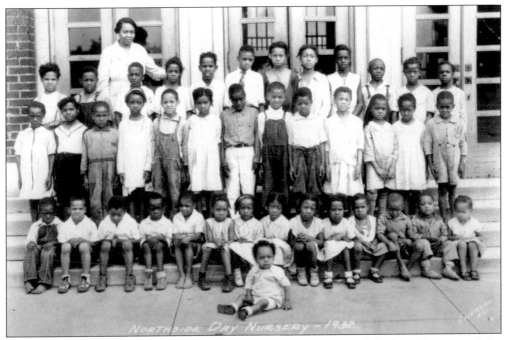

Northside Day Nursery was a Kansas City Urban League–sponsored facility. (Courtesy of the Kansas City Urban League Collection, Missouri State Archives.)

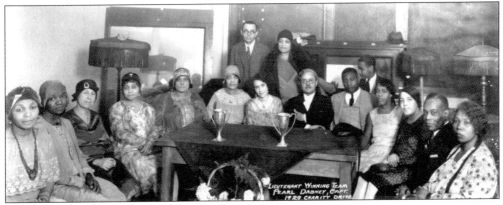

Pearl Dabney was active in the community and is featured in the rear of this 1929 charity drive photograph. In 1925, Dabney served as the general secretary of the local committee for the Negro National Educational Congress. (Courtesy of the Kansas City Urban League Collection, Missouri State Archives.)

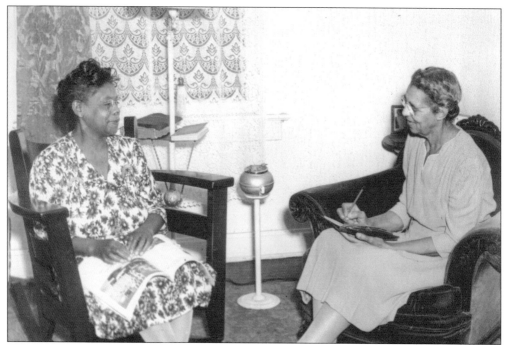

In this photograph, Saline Bolden (left) and Maggie Briggs plan activities for the Kansas City Urban League. (Courtesy of the Kansas City Urban League Collection, Missouri State Archives.)

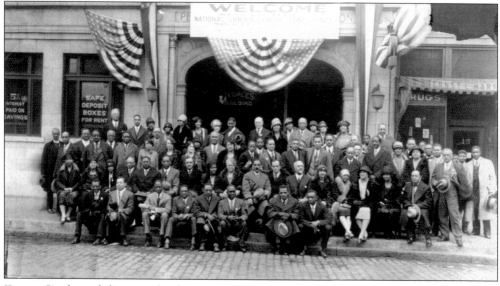

Kansas City hosted the annual Urban League Conference in 1927. (Courtesy of the Kansas City Urban League Collection, Missouri State Archives.)

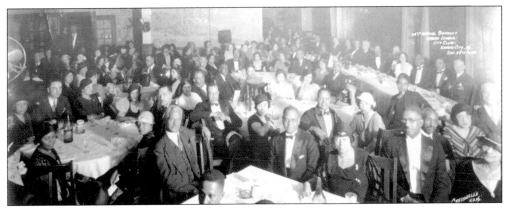

The 14th annual Kansas City Urban League banquet was held on January 30, 1933, at the City Club. (Courtesy of the Kansas City Urban League Collection, Missouri State Archives.)

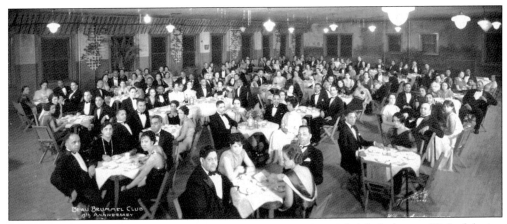

The Beau Brummel Club (originally Bon Vivants) was a men's social club. It was established during World War I to provide "rest and relaxation" for soldiers on leave in the city. During the 1920s, the Beau Brummel Club raised funds through dances, parties, and benefit concerts to support the YWCA, among other worthy causes. (Courtesy of Chris Wilborn and Associates.)

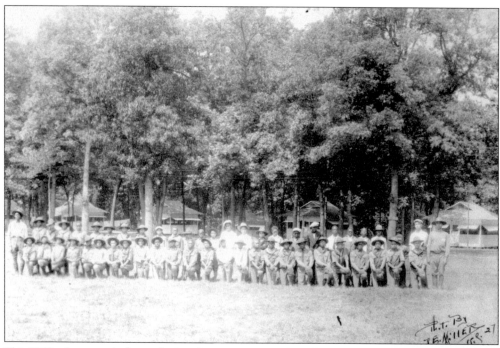

This 1920s photograph shows the Boy Scout troop at Bethel African Methodist Episcopal Church in Kansas City. Scouting at that time was totally segregated in Kansas City, as was the case throughout most of the nation. (Courtesy of William and Annette Curtis.)

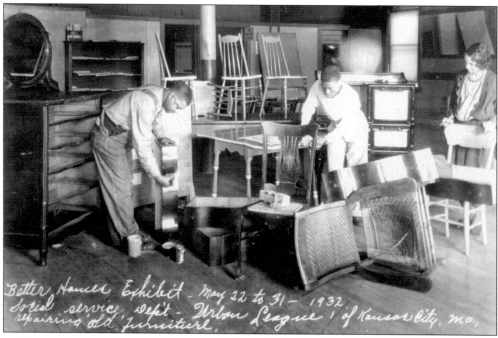

A 1932 Kansas City Urban League homes exhibit shows some of the training options made available to the African American community. (Courtesy of the Kansas City Urban League Collection, Missouri State Archives.)

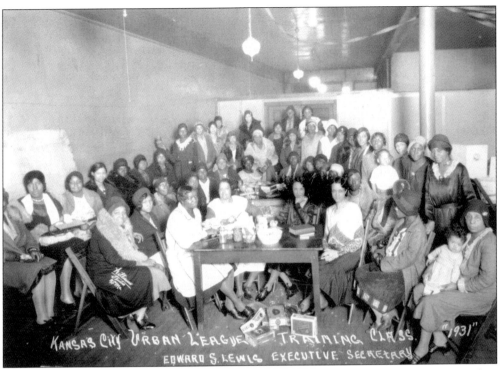

Women were also provided with domestic training as evidenced in this 1931 training class photograph. (Courtesy of the Kansas City Urban League Collection, Missouri State Archives.)

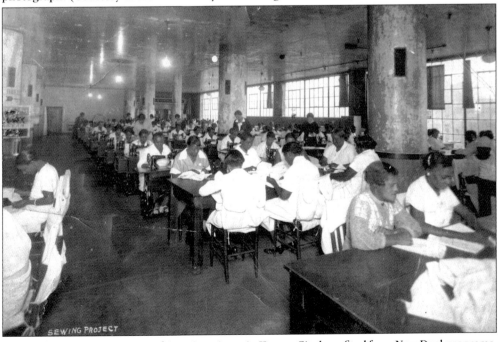

During the Great Depression, African Americans in Kansas City benefited from New Deal programs, including a free Works Progress Administration nursery school, adult educational programs, and sewing instruction. (Courtesy of Dr. Jon Taylor.)

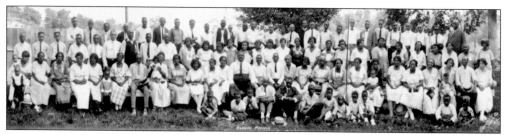

Employees and families pose for a photograph while enjoying the annual Montgomery Ward and Company Porters Picnic at Kansas City's Liberty Park. (Courtesy of the Kansas City Urban League Collection, Missouri State Archives.)

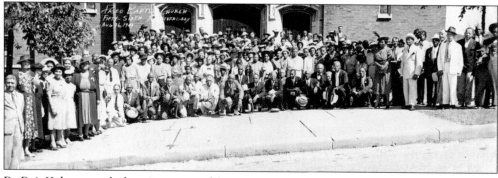

Dr. D. A. Holmes was the longtime pastor of the Paseo Baptist Church. This panoramic photograph was taken on the occasion of the church's 46th anniversary. (Courtesy of William and Annette Curtis.)

Three

KANSAS CITY AND ALL THAT JAZZ

A youthful Jack Bush, destined to become an educator and renowned coach, is pictured here standing on the corner near Eighteenth and Vine Streets. (Courtesy of Jack and Marcheita Bush.)

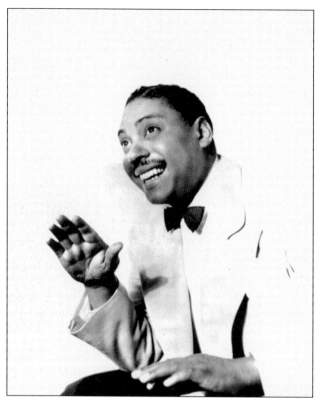

Big Joe Turner immortalized Eighteenth and Vine Streets in the hit song "Piney Brown Blues," an ode to Walter D. "Piney" Brown, the owner of the Sunset Night Club on Twelfth Street. The Grammy award–winning Turner was noted for his "blues shouter" style. (Courtesy of Jimmy Jewell and the Kansas City Museum at Union Station.)

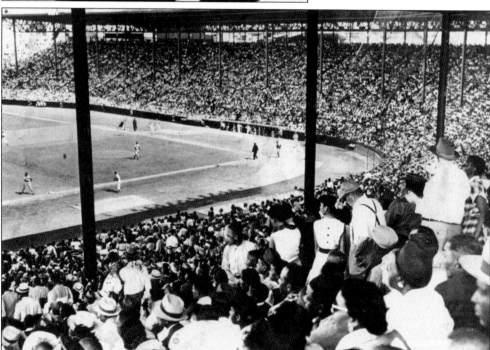

The African American community filled the ballpark at the Kansas City Monarchs versus the Indianapolis Clowns baseball game in 1953. (Courtesy of the Negro Leagues Baseball Museum.)

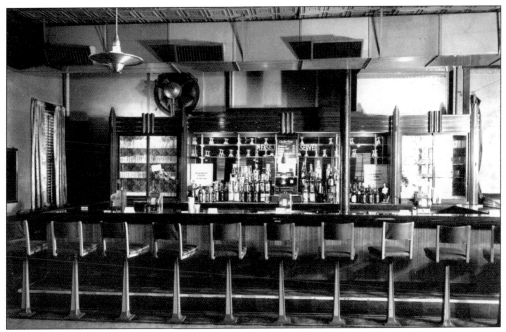

The Blue Room in the Street's Hotel was a famous Kansas City place to be seen in the 1930s. It is now a museum by day, but at night, it comes to life as a working jazz club. The Street's Hotel, owned by Mr. and Mrs. Reuben Street, included the Rose Room and was advertised as "Kansas City's finest restaurant." (Courtesy of Chris Wilborn and Associates and the American Jazz Museum.)

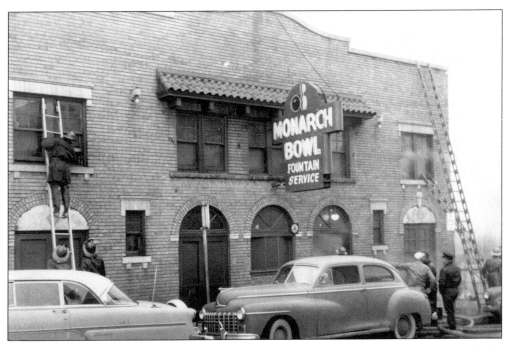

The Eighteenth and Vine Streets business district included barbershops, restaurants, taxicabs, dry cleaners, drugstores, loans offices, and recreational activities like movie theaters and the Monarch Bowl. (Courtesy of the Black Archives of Mid-America.)

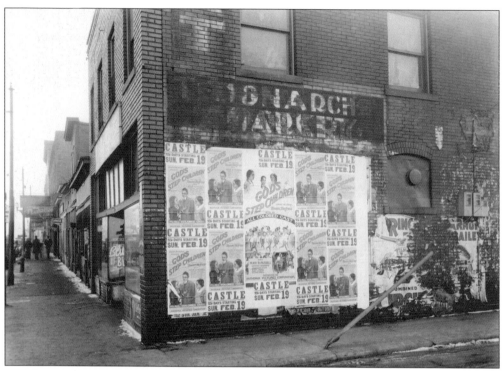

Monarch Market was located at Eighteenth Street and Lydia Avenue. (Courtesy of the American Jazz Museum.)

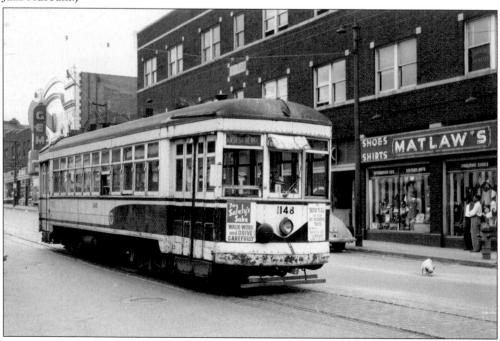

This trolley ran along Eighteenth Street. Matlaw's was an important clothing store for African Americans since they could not shop freely at the major downtown department stores. (Courtesy of the American Jazz Museum.)

Black Hawk Barbeque and Outdoor Beer Garden was located at 1410 East Fourteenth Street. The eatery was owned and operated by Mr. and Mrs. W. H. Spivey. Its advertisements boasted "southern hickory meats of all kinds, Mexican chili, and good cold beers." (Courtesy of the American Jazz Museum.)

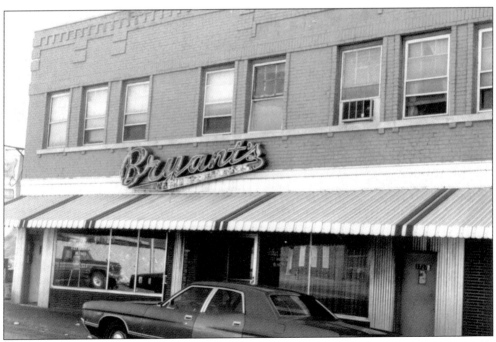

In 1907, Henry Perry was a barbecue pioneer and established the forerunner of the internationally acclaimed Arthur Bryant's located at 1727 Brooklyn Avenue. (Courtesy of the Living History Collection, Joe Mattox.)

YULETIDE GREETINGS

FROM

KENTUCKY BAR-B-Q

BRIGHT SPOT OF KANSAS CITY

19th & VINE GR. 9122

Featuring a Big Floor Show Every Nite

WOODY WALDERS AND HIS SWINGSTERS

WALTER BROWN, Vocalist

*Serving the best of food. Well known drink mixtures
With the best of liquors*

"GIRL FROM THE PHILIPPINES"

New faces in the floor show

Old Kentucky Bar-B-Q was established in the 1940s by George W. Gates. It was particularly renowned for its sauce. The business is known today as Gates BBQ, where the customers are greeted with "Hi, may I help you?" (Courtesy of the Kansas City Museum at Union Station.)

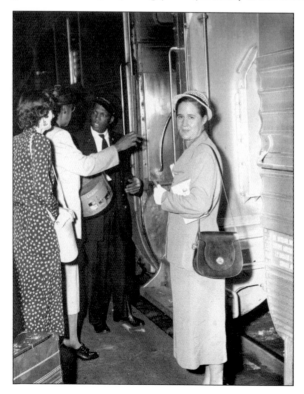

An unidentified Pullman car porter helps boarding passengers at Kansas City's Union Station. Employment as a train porter provided travel opportunities, as well as secure and well-paying wages for African American men. (Courtesy of William and Annette Curtis.)

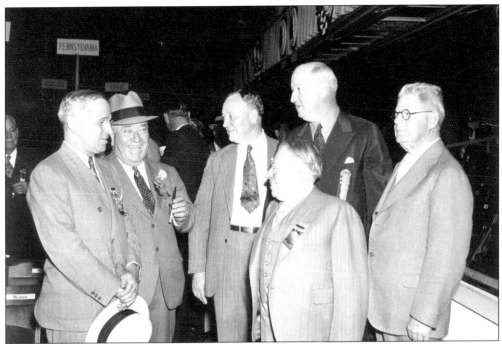

"Boss" Tom Pendergast (with cigar) is shown talking to Harry S. Truman and unidentified Democratic supporters. Pendergast policies aided the African American community. Jazz musicians could always find work in Kansas City. (Courtesy of the Harry S. Truman Library and Museum.)

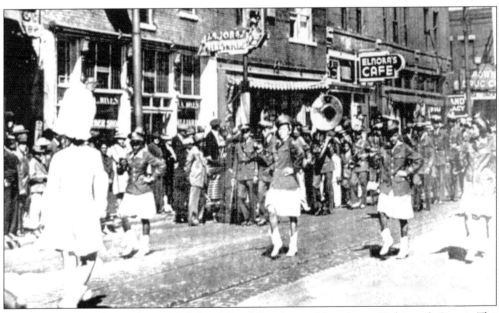

This photograph shows the R. T. Coles School Band marching down Eighteenth Street. The school's namesake, Dr. Richard Thomas Coles, was a prominent educator who supported Booker T. Washington's belief in manual education. The building at Nineteenth Street and Tracy Avenue was converted to a junior college and vocational school in the 1930s. (Courtesy of William and Annette Curtis.)

Julius B. Jones was the owner of Jones Billiard Parlor located at 1514 East Eighteenth Street. The original building still stands amid the renovations of the historic district. The building at the far left is the original location of the famed Street's Hotel and the current home of the Peachtree Restaurant of Kansas City. (Courtesy of the Jazz District Redevelopment Corporation.)

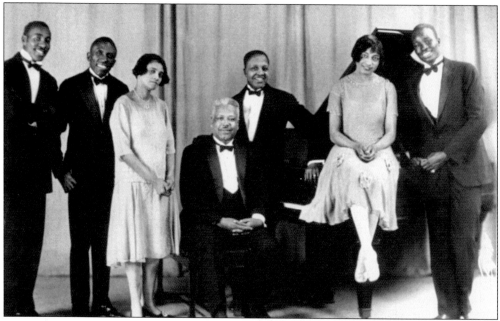

Dean Jackson (seated at piano), the director of music at Western University, organized the Jackson Jubilee Singers to become ambassadors of goodwill throughout the northern central states. They performed in chautauquas each summer. Etta Moten is sitting on the piano. She became a noted jazz singer and lived in Chicago. (Courtesy of William and Annette Curtis.)

Bennie Moten was Kansas City's preeminent bandleader in the 1920s. The Bennie Moten Orchestra reached even greater heights when pianist Bill Basie, known as Count Basie, joined the group in 1929. After Moten's untimely death in 1935, Count Basie was instrumental in continuing the development of the "Kay Cee" style of jazz. (Courtesy of the Kansas City Museum at Union Station.)

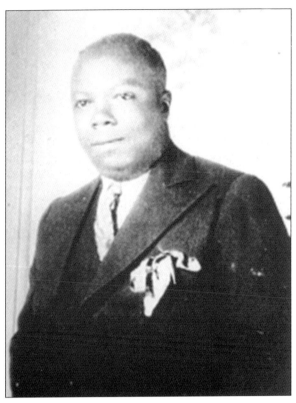

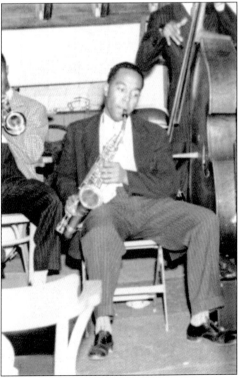

Kansas City is home to not one but two internationally renowned saxophonists, Ben Webster and Charlie "Yardbird" Parker. Parker attended Lincoln High School. The originator of bebop, Parker's favorite nightclub to perform in was the Subway at Eighteenth and Vine Streets. The building where the Subway was located was razed in the early 1980s. Parker died from drugs in 1954 and was buried in Lincoln Cemetery on 8604 Truman Road in Kansas City. (Courtesy of the American Jazz Museum.)

> 4121 M. Kinley
> April 3, 1946
>
> I, Charlie Parker
> do here by sign
> one half, (½), of
> royalties concerning
> all contracts with
> Dial Record company
> over to the undersigned
> Imery Byrd
>
> Charles Parker
> (i.e.)
> Emry Byrd

This is Charlie Parker's royalty agreement with Dial Records. (Elvis Sonny Gibson Collection, Bruce R. Watkins Cultural Heritage Center.)

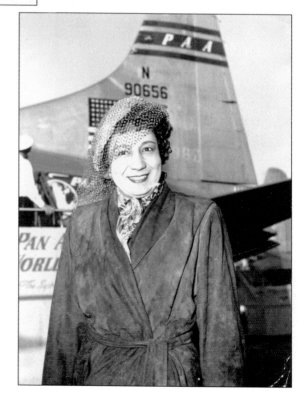

Etta Moten left her native Kansas City to become internationally famous. She relocated to Chicago and married newspaperman Claude Barnett. (Courtesy of Pan American Airways and the Kansas City Call.)

Myra Taylor was a noted jazz singer, writer, and recording artist of the 1930s and 1940s in Kansas City. Taylor was also a USO performer during World War II, the Korean War, and the Vietnam War. She wrote, published, and recorded the No. 1 hit "The Spider and the Fly" in 1946. (Courtesy of Jimmy Jewell and the Kansas City Museum at Union Station.)

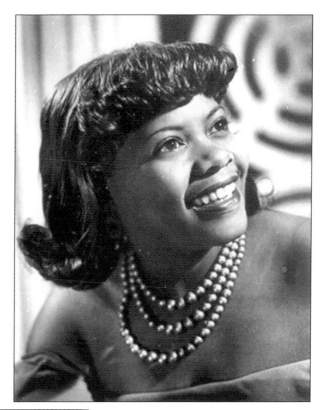

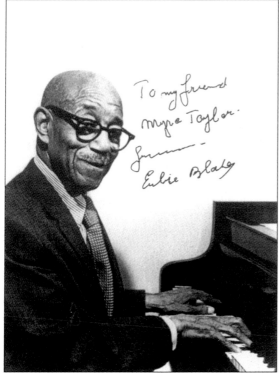

The legendary Eubie Blake was Myra Taylor's pianist during the World War II era. (Courtesy of William and Annette Curtis.)

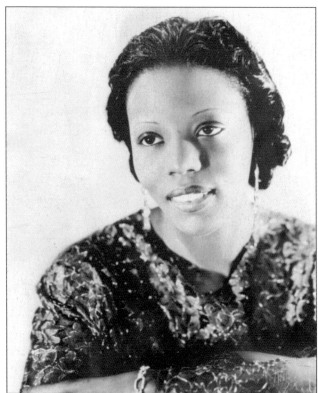

Mary Lou Williams was a phenomenal pianist whose career began in Kansas City. Andy Kirk's *The Lady Swings the Band* honors Williams's talent and respect among her fellow musicians. (Courtesy of the Goin' to Kansas City Collection, Kansas City Museum at Union Station.)

Julia Lee was married to Negro Leagues baseball player Frank Duncan. They had one child, Frank Duncan Jr. For 14 years, Lee was a part of her brother's group the George Lee Orchestra. (Courtesy of the Kansas City Museum at Union Station.)

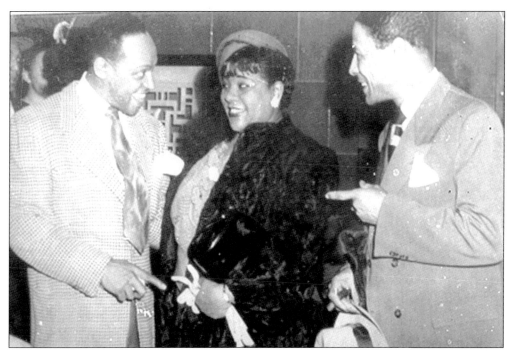

In the 1940s, Julia Lee sold over one million records, including her hit "Snatch and Grab It." She also performed at the White House at the request of Pres. Harry S. Truman. (Courtesy of the Kansas City Museum at Union Station.)

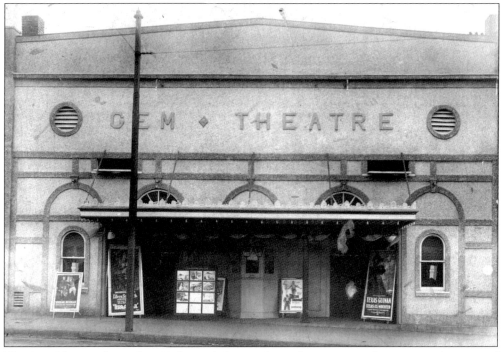

The Gem Theatre, located on Eighteenth Street, showed B movies and westerns. (Courtesy of the Kansas City Call.)

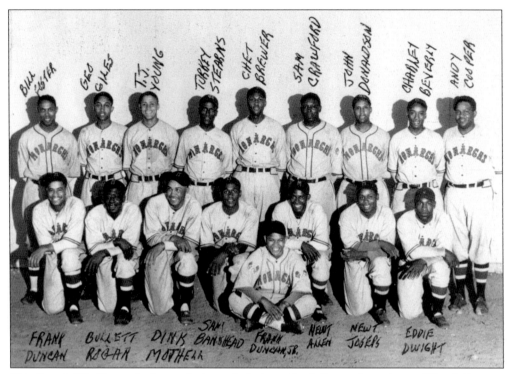

This Kansas City Monarchs team photograph features the father and son team of Frank Duncan and Frank Duncan Jr. (Courtesy of the Negro Leagues Baseball Museum.)

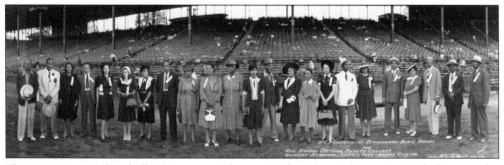

The Negro Leagues baseball games were at the center of many social activities, including parades and the beauty pageants. This panoramic photograph captures the second annual bathing beauty contest on September 1, 1940. (Courtesy of the Negro Leagues Baseball Museum.)

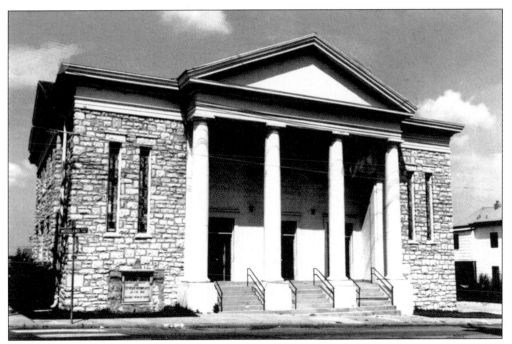

Centennial United Methodist Church, located at 1834 Woodland Avenue, will celebrate its 100th anniversary in March 2007. Centennial was the site of Bennie Moten's funeral after he died of heart failure during a tonsillectomy at Wheatley-Provident Hospital in 1935. (Courtesy of William and Annette Curtis.)

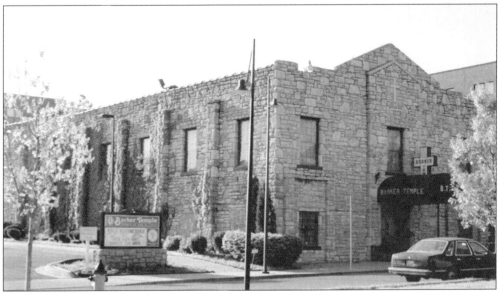

Barker African Methodist Episcopal Temple is also an anchor in the Historic Eighteenth and Vine District. (Courtesy of the Living History Collection, Joe Mattox.)

The Negro Leagues baseball was organized at the Kansas City Paseo YMCA. (Courtesy of William and Annette Curtis.)

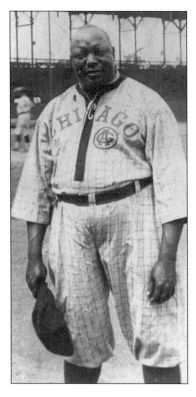

In 1920, Andrew "Rube" Foster organized the Negro Leagues baseball at the Paseo YMCA. (Courtesy of the Negro Leagues Baseball Museum.)

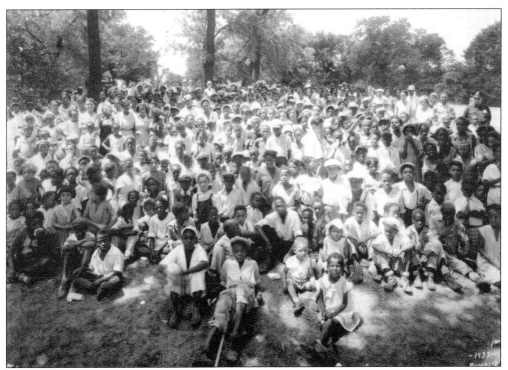

This is a 1933 picnic photograph possibly taken on the famed and segregated Watermelon Hill. (Courtesy of the Kansas City Urban League Collection, Missouri State Archives.)

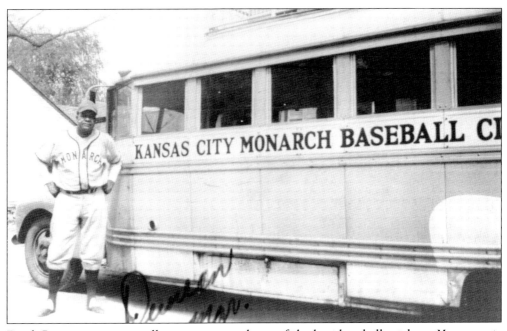

Frank Duncan was an excellent manager and one of the best baseball catchers. Many sports historians agree that racism kept him from the major leagues. (Courtesy of the Negro Leagues Baseball Museum.)

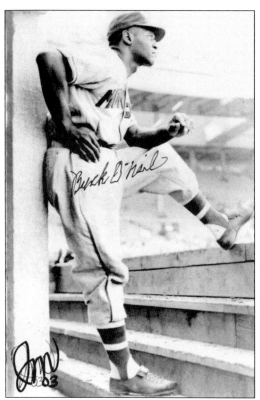

John Jordan "Buck" O'Neil spent his entire life enjoying baseball and breaking down the barriers of segregation. During his baseball career, he played with the Memphis Red Sox and the Kansas City Monarchs. O'Neil became the first African American coach for the Chicago Cubs in 1962. He helped to found and promote the Negro Leagues Baseball Museum. Still a record breaker, O'Neil, at age 94, became the second-oldest person to ever play in a professional baseball game, appearing with the Kansas City T-bones on July 18, 2006. (Courtesy of the Negro Leagues Baseball Museum.)

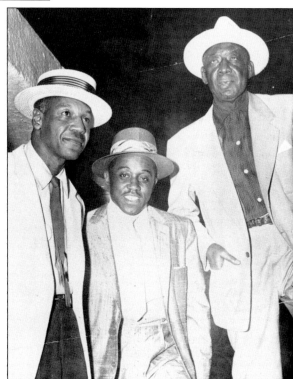

Buck O'Neil is pictured with Ted Rasberry (center) and Wilber "Bullet" Rogan (right). (Courtesy of the Negro Leagues Baseball Museum.)

Jackie Robinson played with the Kansas City Monarchs before he desegregated major-league baseball in 1947. (Courtesy of the Library of Congress.)

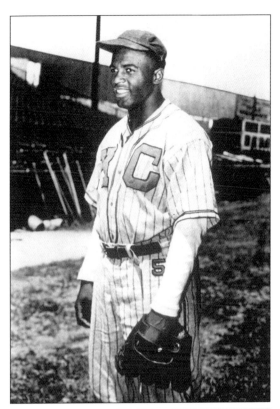

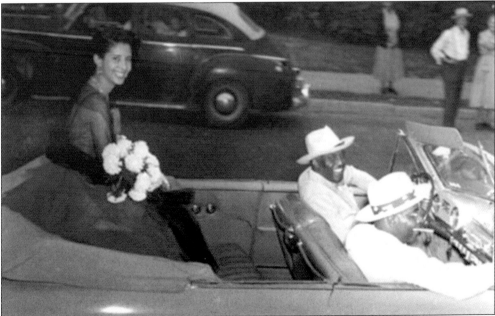

Pictured here is a Kansas City parade with Chauncey Downs at the driver's wheel. Downs was the founder of the Heart of America Training School. The charismatic musician, civic leader, and businessman was also the proprietor or host of the Casa Loma Ball Room and Club 30 at 1803 Prospect Avenue. (Courtesy of the Black Archives of Mid-America.)

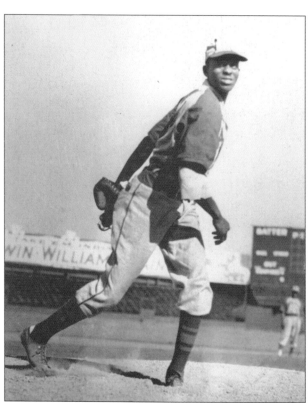

Satchel Paige is shown pitching. (Courtesy of the Negro Leagues Baseball Museum.)

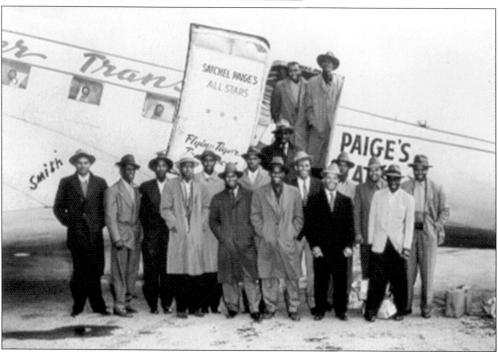

Satchel Paige's All-Stars appear here. (Courtesy of the Hilton Smith family and the Kansas City Museum at Union Station.)

Pictured here is Satchel Paige's home. (Courtesy of William and Annette Curtis.)

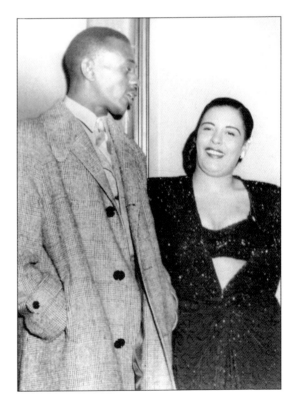

Satchel Paige is photographed here with the lovely Billie Holliday. (Courtesy of Noirtech Research.)

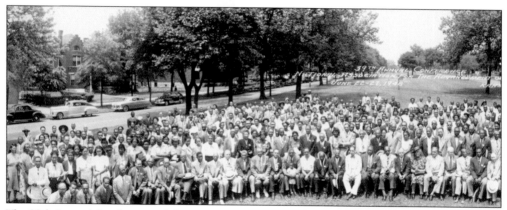

The 39th Annual Conference of the National Association for the Advancement of Colored People (NAACP) was held on June 22–27, 1948, in Kansas City. This panoramic photograph was taken on the Paseo Boulevard, and the first row includes Walter White, Daisy Lampkin, Channing Tobias, Roy Wilkins, Gloster Current, Kelly Alexander, Ruby Hurley, and Lucille Black. During the 1940s, Kansas City attorney Carl M. Johnson was the first Missourian elected to the National NAACP Board. (Courtesy of the Library of Congress and Chris Wilborn and Associates.)

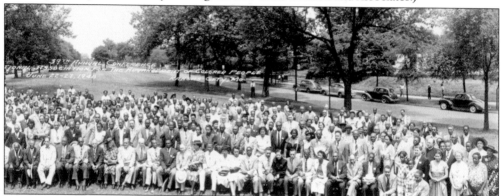

Four

MAKING CIVIL WRONGS CIVIL RIGHTS

On June 29, 1947, Pres. Harry S. Truman addressed the NAACP. Truman was the first American president to include civil rights in his political platform. One year later, he issued Executive Order 9981, which desegregated the United States armed forces. The war and its aftermath had a profound effect on the nation. Movement toward equality and civil rights was evident in Kansas City as well. For example, Truman nominated Kansas City businessman and civic leader Earl W. Beck as the recorder of deeds for the District of Columbia in 1952. (Courtesy of the Harry S. Truman Library and Museum.)

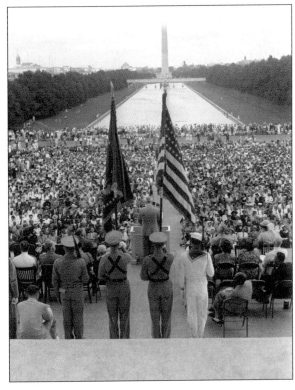

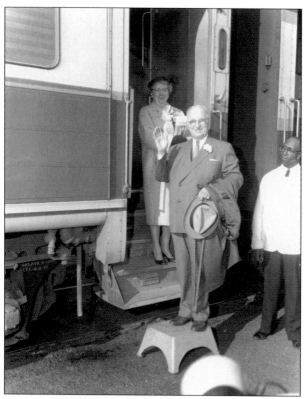

Pres. Harry S. Truman and wife Bess are pictured on the train with an African American porter. A. Philip Randolph organized the Pullman Porters in the Brotherhood of Sleeping Car Porters. Because of his leadership and the quality of the men, this became the most powerful African American labor union and the first to be admitted into full fellowship with the Congress of Industrial Organizations, a national labor organization. (Courtesy of the Harry S. Truman Library and Museum.)

This unidentified African American woman war worker from Kansas City symbolizes African American commitment to the Double V Campaign, or victory at home and abroad in fighting discrimination. In 1941, the NAACP sponsored a wartime rally at Memorial Hall to secure African American employment in the war production plants. The keynote speaker, Dr. A. Porter Davis, addressed an audience of nearly 5,000 concerned Kansas Citians. Pres. Franklin D. Roosevelt's Executive Order 8802, which banned defense contractors from discrimination on the basis of race in employment practices, was issued on June 25, 1941. (Courtesy of the Library of Congress.)

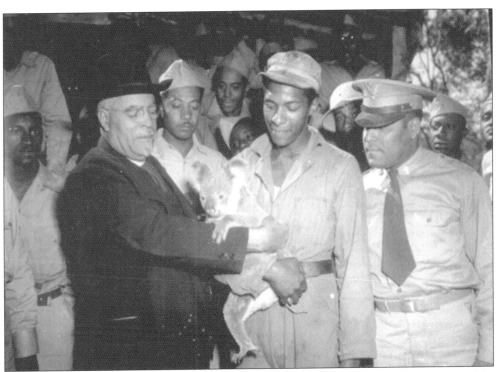

In this photograph, Bishop John Andrew Gregg talks with World War II troops. (Courtesy of the National Archives.)

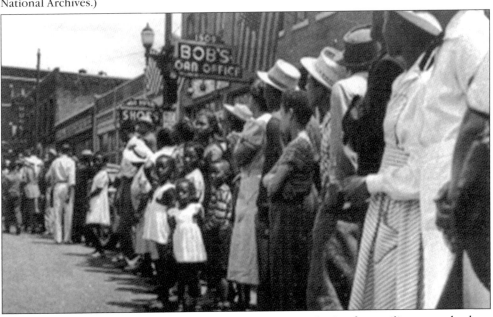

This photograph shows the African American community gathering for a military parade along Eighteenth Street. Chester A. Franklin, editor and publisher of the *Kansas City Call*, led the African American community with the Brown Bomber War Bond Campaign, raising more than $300,000 for the war effort and the purchase of the military bomber. (Courtesy of the Kansas City Museum at Union Station.)

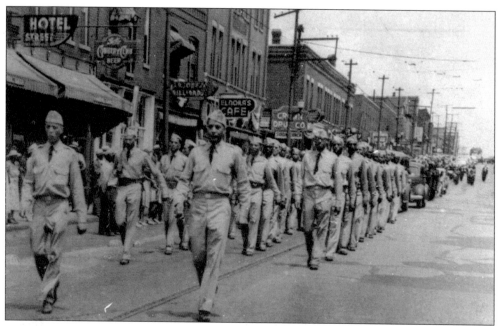

World War II soldiers march in a military parade along Eighteenth Street. Many Kansas Citians like Albert O. Bly, Jack Bush, Lloyd Canton, Alvin Ferguson, Leon Jordan, Buck O'Neil, Bruce R. Watkins, and William Shelton answered the call to arms. Shelton was a railway mail clerk who earned a Silver Star Medal. He also served on the board of directors for the Douglass State Bank. (Courtesy of the Kansas City Museum at Union Station.)

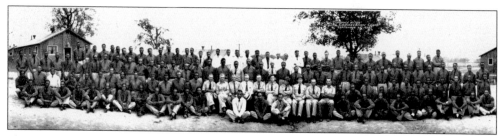

This Depression-era Civilian Conservation Corps camp in nearby Liberty aided in the training and preparation of African Americans for the coming war. (Courtesy of Chris Wilborn and Associates.)

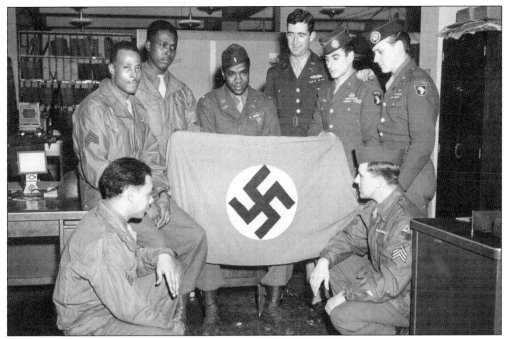

These World War II soldiers display a captured Nazi flag on March 1, 1945. Pictured are, from left to right, Henry C. Cogola, James E. Colucci, James H. Cruickshank, Elmer K. Forrest, Samuel B. Hendrix, Walter J. McDowell, Hugh D. Thompson, and Frederick R. Wheeler. (Courtesy of the Harry S. Truman Library and Museum.)

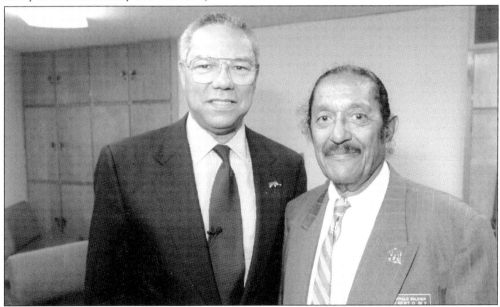

In 1998, the Harry S. Truman Library, the University of Missouri–Kansas City, and the African American Military Historical Association hosted a weeklong celebration honoring the 50th anniversary of Executive Order 9981. Retired general Colin Powell was the keynote speaker. Powell (left) is pictured with retired lieutenant Albert O. Bly, president and cofounder of the African American Military Historical Association. (Author's collection.)

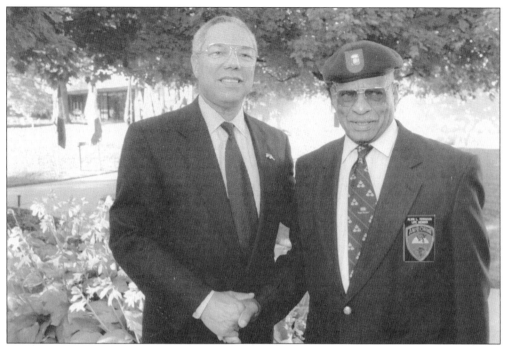

Gen. Colin Powell greets Kansas City area resident Alvin Ferguson of the 555th Airborne Division. The "Triple Nickels" was the first African American unit to become a part of the 82nd Airborne Combat Division. (Author's collection.)

Jack Bush and friends were photographed while on R & R in the Pacific theater. (Courtesy of Jack and Marcheita Bush.)

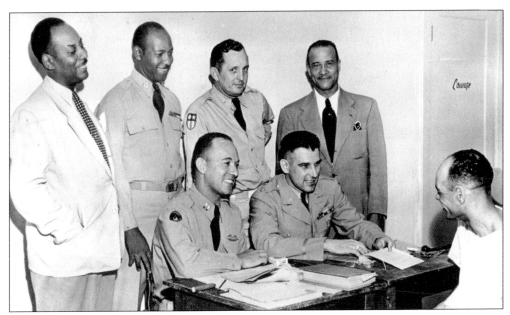

On August 4, 1949, the federal government recognized the 242nd Combat Engineer Battalion. This National Guard recruitment office photograph shows, standing, from left to right, Kansas City Urban League director Lounneer Pemberton, Capt. Charles Gates, Col. Harold L. Taylor, and state legislator J. McKinley Neal. Seated are Harold Perkins (left) and Capt. Charles R. Penrose behind the desk and Col. William Dudley. Gates was the first to command the 242nd. He rose to the rank of lieutenant colonel during his military career. (Courtesy of the Museum of Missouri Military History, Jefferson City.)

Charles Gates, a cofounder of the African American Military Historical Association, was a member of the 761st Tank Battalion during World War II. The 761st Tank Battalion was one of the first American units to liberate the Nazi concentration camps. Gates was the recipient of the Bronze Star, Silver Star Medal, Purple Heart, and the European African Theater Campaign Ribbon with four Bronze Stars. Funeral services were held at Ebeneezer Baptist Church on June 17, 1997, for "Pop" Gates, as he was affectionately known. (Courtesy of the Museum of Missouri Military History, Jefferson City.)

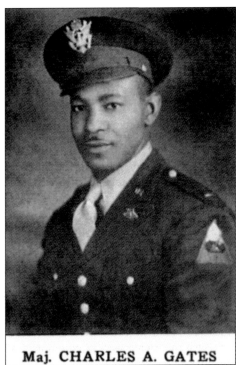

Maj. CHARLES A. GATES

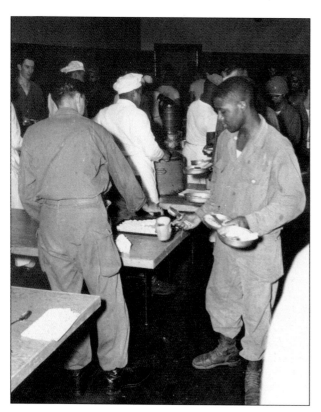

This photograph of the 242nd Combat Engineer Battalion, Missouri National Guard, was taken during flood duty. (Courtesy of the Museum of Missouri Military History, Jefferson City.)

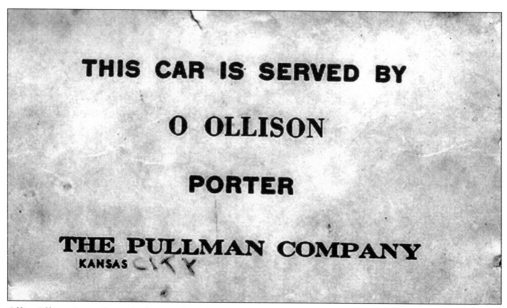

THIS CAR IS SERVED BY

O OLLISON

PORTER

THE PULLMAN COMPANY
KANSAS CITY

Ollie Ollison's card reminds one that during segregation a position as a porter was prestigious because of the limited job opportunities. Porters wore smart-looking uniforms and did not perform manual labor. (Courtesy of Maxcine Webster and the Kansas City Museum at Union Station.)

During World War II, African Americans filled a variety of duties. Mae Forester was photographed performing her clerical duties. (Courtesy of the Kansas City Call.)

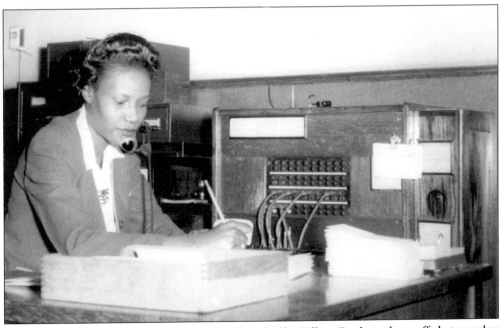

Telephone operator Madeline Srivder was photographed by William Fambrough, a staff photographer and engraver for the *Kansas City Call*. His ability to capture the essence of his photograph with one click of the camera made him famous as "One-Shot Fambrough." (Courtesy of the Kansas City Call.)

This photograph shows Marcheita Bush enjoying a Lincoln University football game in Jefferson City. Until the 1940s, African Americans in Kansas City almost exclusively attended Lincoln University or an out-of-state school because the doors of most Missouri colleges and universities were closed to them. (Courtesy of Jack and Marcheita Bush.)

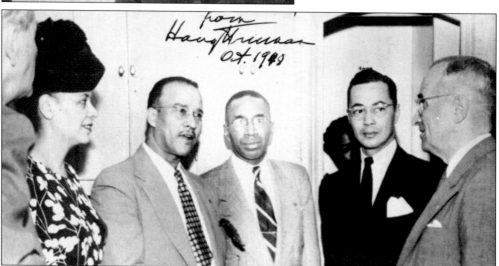

This photograph shows Pres. Harry S. Truman meeting with, from left to right, press secretary Charles Ross, Ann Hedgman, state legislator J. McKinley Neal, Robert Sweeney, and Louis W. Clymer on his private train car, *Ferdinand Magellan*. Neal was the second African American to be elected to the Missouri state legislature, in 1948. Sweeney enjoyed a 38-year career with the U.S. Postal Service. In 1948, he was named the first African American supervisor in Kansas City. Clymer was an assistant prosecuting attorney of Jackson County. During World War II, the Howard University graduate was employed with the War Manpower Commission. In 1955, Clymer ran for the elected office of councilman-at-large. (Courtesy of the Harry S. Truman Library and Museum.)

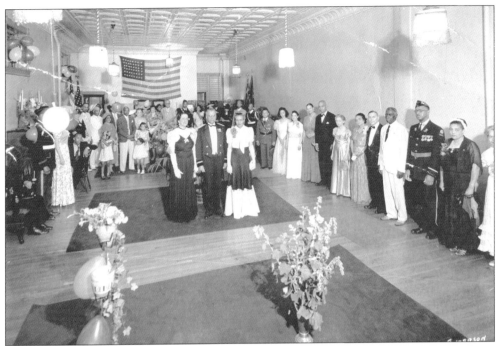

Kansas Citians hosted a reception for Brig. Gen. Benjamin O. Davis Sr. Notable citizens in attendance included Chester A. and Ada Crogman Franklin, as well as Dr. J. E. Perry. Davis retired in 1948 with a military career that spanned 50 years. (Courtesy of the Kansas City Call.)

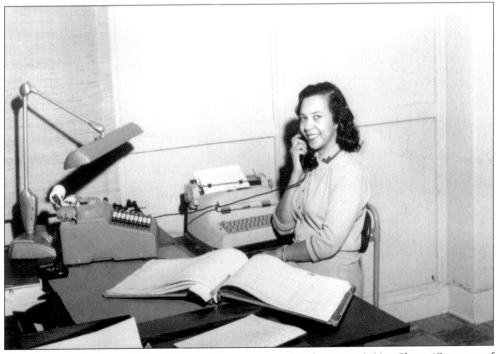

This photograph shows Shirley Hill, an office manager at Jack Norman's Men Shop. (Courtesy of the Black Archives of Mid-America.)

These young girls were featured in the June Watts dancers. (Courtesy of the Elijah Washington Collection, Black Archives of Mid-America.)

Marcheita Bush is shown with her class at R. T. Coles Junior and Vocational High School. Many of the school's clubs affiliated with the Y-teen department of the YMCA and YWCA. Students also benefited from veteran teachers like masonry instructor William A. Smith and renowned seamstress Elizabeth Cecil Cotton. (Courtesy of Jack and Marcheita Bush.)

This photograph shows Jack and Marcheita Bush's daughter Lynn Bush Boyer (far right) enjoying her cousins and friends. (Courtesy of Jack and Marcheita Bush.)

Families in Kansas City's African American neighborhoods were similar to most American families with more than four children, two parents in the home, working fathers, and perhaps stay-at-home mothers. Willmun Suber Sr. and Mamie Marcell Suber's family included Meadrica McDonald, 15; Shirley Marcelle Milligan, 13; Willmun Suber Jr., 11 (deceased); Theretha Suber, 9; Carolyn Juanita Suber, 7; and Kenneth Suber, 2. (Courtesy of Mamie Marcell Suber.)

Dr. Carrie Dunson (seen third from the left in the rear) lived with her great-aunt at 2612 Brooklyn Avenue before her family moved to 1115 East Twenty-second Street where she attended Charles Sumner School. The house on Brooklyn Avenue is still standing, but the house on East Twenty-second Street is now a vacant lot. The Charles Sumner School is no longer there. In its place is Truman Hospital, formerly General Hospital No. 2. (Courtesy of Dr. Carrie Dunson.)

While African American neighborhoods sheltered children from the ills of segregation, it was often difficult to do so in public spaces like parks, restaurants, department stores, or even swimming pools. This "colored" pool was located at Twenty-seventh and Woodlawn Streets. In 1951, the NAACP lawsuit *City of Kansas City v. Ester Williams* involved the desegregation of the swimming pool at the municipal Swope Park. (Courtesy of the Missouri State Archives.)

Rev. Israel Boyd S. Groves Jr. and Evangeline Groves were wed on December 8, 1965, in the home of the groom's parents. Israel worked for Southwestern Bell as one of the first black telephone repairmen in the city and retired after more than 30 years of service in 1998. Evangeline worked for Western Electric for several years but retired after the birth of their third child. (Courtesy of Crystal Lumpkins.)

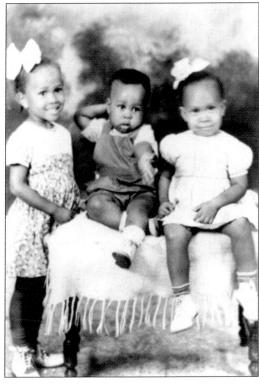

Dr. Dorether Welch is pictured here at age five with sister Yvonne, age three, and brother Jodie Jr., age one, in the late 1940s. (Courtesy of Dr. Dorether Welch.)

African American women have provided nurturing and sustenance not only for their families but for the wider community through employment as maids, cooks, and nannies. Many were loved and deeply respected by their surrogate families, including Ruth Wilson Gaskin, shown here with her young charge Dick in 1951. (Courtesy of Dr. Irene Starr.)

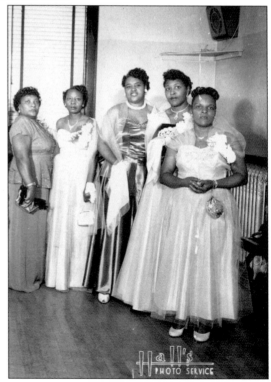

Ruth Wilson Gaskin (left), originally from El Dorado, Arkansas, is seen here wearing elegant evening apparel. (Courtesy of Dr. Irene Starr.)

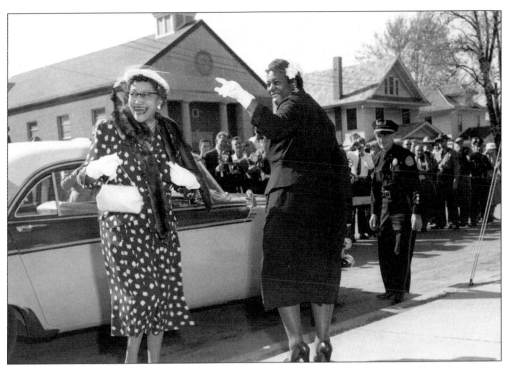

Vietta Garr (left) and Leola Estes wave at the crowd while attending the wedding of Margaret Truman Daniel. (Courtesy of the Harry S. Truman Library and Museum.)

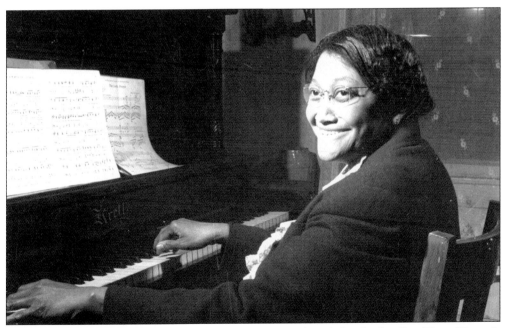

Vietta Garr, playing the piano, was the housekeeper and cook for the family of Pres. Harry S. Truman. She helped train the White House staff to serve the Trumans. She also cared for Mother Wallace. The Trumans built a small home for Garr in the early 1950s. (Courtesy of the Harry S. Truman Library and Museum.)

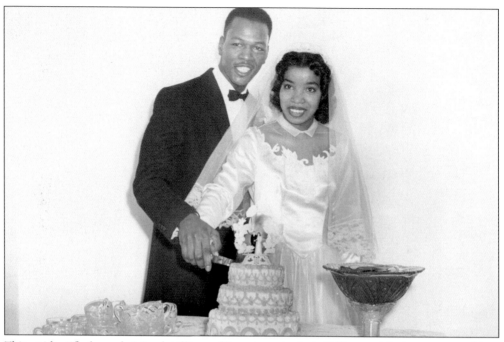

This unidentified couple joined millions of Americans in their 1950s nuptials. However, wedding ceremonies in the African American community, especially the photographs, tended to reflect the centrality of community as opposed to simply showcasing the bride. (Courtesy of the Elijah Washington Collection, Black Archives of Mid-America.)

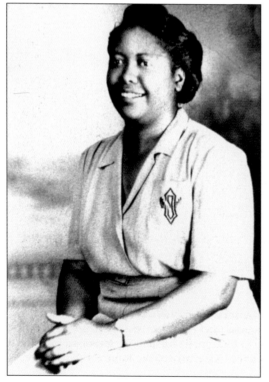

Helen Patton attended Young School and graduated from Lincoln High School. She was exceptionally bright and graduated with honors when she was 14 in the early 1930s. She then attended Lincoln University and finished college when she was 18. The school provided a chaperone at all times for her because she was so young. Despite her intelligence, segregation closed the doors of employment to her because of her color. After years of substandard employment, she finally landed a job at Crown Drug Store at Eighteenth and Vine Streets. (Courtesy of William and Annette Curtis.)

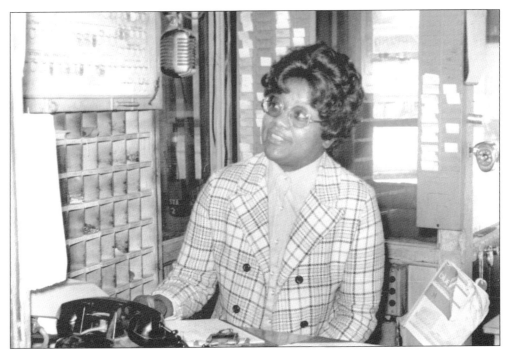

Continuing the postal traditions of Jim Nash, Harry Johnson, James Crews, and Robert Sweeney, among many others, Lena Briscoe was Kansas City's first African American female postal supervisor. (Courtesy of the Kansas City Call.)

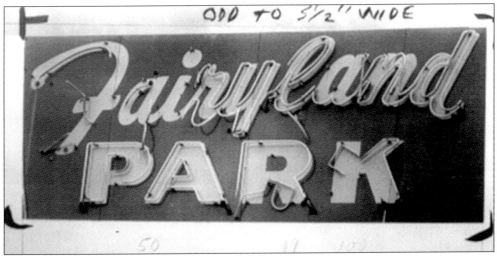

Fairyland Park was built in 1923 at 7501 Prospect Avenue. It featured a Ferris wheel, the Skyrocket, the Whip, and segregation. African Americans in Kansas City deeply resented "Jim Crow" at Fairyland Park, especially when jazz greats like Harlan Leonard, Andy Kirk, and Jay McShann performed on the outdoor pavilion to a segregated audience. (Courtesy of the Kansas City Museum at Union Station.)

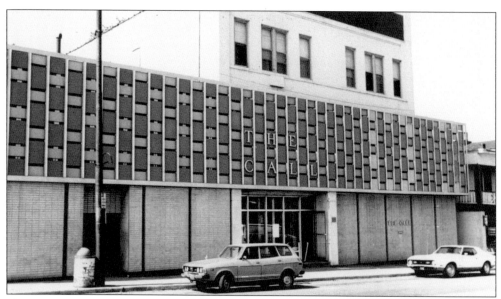

The Kansas City Call Building remained an anchor in the African American community during the segregation and desegregation eras. The second floor included the Franklin family's apartment. Chester A. Franklin used the *Kansas City Call* as an instrument of social justice to promote African American interests on a myriad of issues, including antilynching laws, jury representation, defense industry employment, school integration, and fair housing. When Chester passed away in 1955, Ada Crogman Franklin managed the newspaper and continued to live in the apartment until her death in 1983. (Courtesy of the Kansas City Call.)

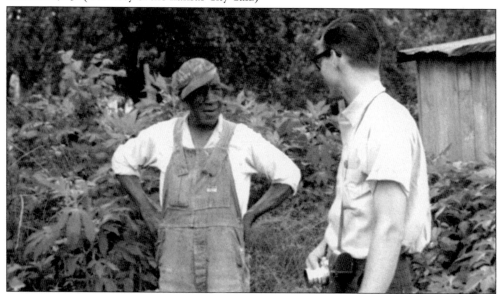

Urban renewal had a profound effect on the African American neighborhoods of the Kansas City area. It targeted them far more than any other and displaced large numbers of African American families. In this 1961 photograph, an urban renewal field-worker interviews Israel Cooper, a resident of the large African American neighborhood in Independence. Cooper died during the process of watching his beloved neighborhood get dismantled to make way for the city park across from the Harry S. Truman Library and Museum. (Courtesy of William and Annette Curtis.)

Five

POWER TO THE PEOPLE

While Israel Cooper and many others lacked the power to keep their neighborhood intact, changes did take place in the Greater Kansas City area that allowed African Americans to harness the power of electoral politics. This was the case of Bruce R. Watkins, who was inspired by T. B. Watkins in 1956 to enter politics. In 1962, with Leon M. Jordan, Watkins created a political organization called Freedom Inc. to galvanize African American voters. Bruce R. Watkins became the first African American to serve on Kansas City's city council. In 1966, he was elected as the first black circuit clerk of Jackson County and won reelection in 1970. In 1975, he was again elected to the city council of Kansas City to represent the Sixth District. In 1979, he campaigned for mayor but was defeated by Richard Berkley by 20,000 votes. (Courtesy of the Kansas City Call.)

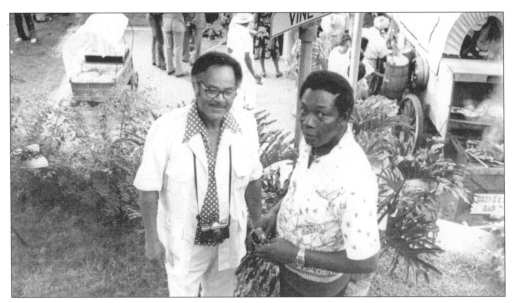

Bruce R. Watkins (left), on Eighteenth and Vine Streets, actively participated in many community organizations, boards, and committees. He was also a driving force in the family business, Watkins Brothers Memorial Chapels, Inc. After an exhausting battle with cancer, the former Tuskegee Airman died on September 13, 1980. Dignitaries at his funeral included Vice Pres. Walter Mondale, Sen. Thomas Eagleton, Sen. Harry Wiggin, Congressman William Clay, Congressman Richard Bulling, Gov. Joseph Teasdale, and Watkins's former political opponent, the newly elected Mayor Richard Berkley. (Courtesy of the Kansas City Call.)

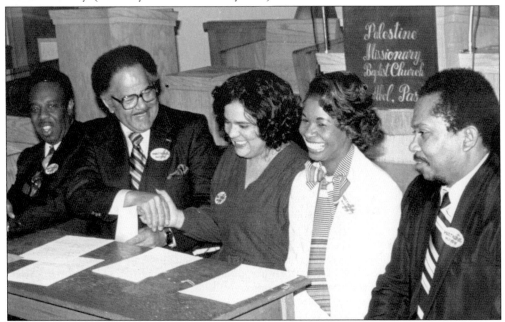

Rev. Earl Abel (left) looks on as Bruce R. Watkins receives an endorsement by teachers in his election bid. Watkins's success, as well of that of Freedom Inc., depended on the mass mobilization of voters. Freedom Inc. remains the oldest African American political organization in the United States. (Courtesy of the Kansas City Call.)

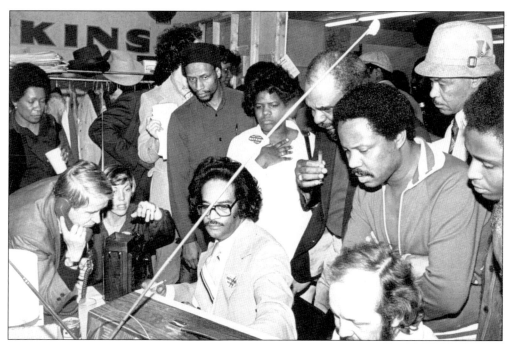

Besides Leon Jordan and Bruce R. Watkins, Fred Curls, Judge Leonard Hughes Jr., Mamie Hughes, Rose Mary Lowe, Charles Moore, and Howard Mopin were instrumental in building Freedom Inc. In this photograph, supporters await election results. Freedom Inc. taught the African American community how to "use your vote." (Courtesy of the Kansas City Call.)

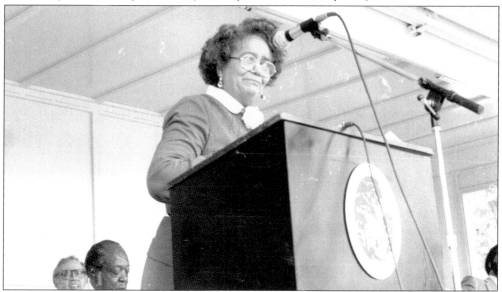

Gertrude Keith speaks at the dedication of the Spirit of Freedom Fountain in September 1981. The fountain, located near the Bruce R. Watkins Heritage Center, honors Watkins's civil rights work. Keith, a civic activist in her own right, was the first African American women to serve on the Kansas City School Board. She was also the first manager of the Wayne Miner Housing Project and deputy director of the Land Clearance for Redevelopment Authority. (Courtesy of the Kansas City Call.)

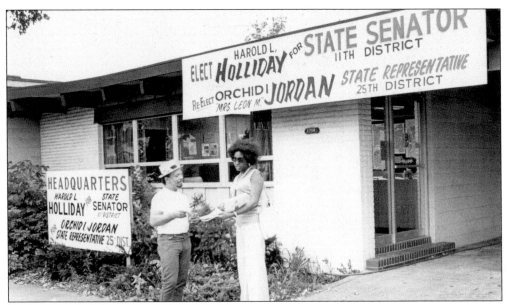

In this photograph, campaign workers talk outside the headquarters of the Harold Holliday and Orchid Jordan campaign. Holliday was the first African American to graduate from the University of Kansas City (now University of Missouri–Kansas City) law school. He was admitted to the Missouri bar in 1952. Jordan was the widow of slain civil rights leader and Freedom Inc. cofounder Leon M. Jordan. Orchid Jordan served 16 years in the Missouri House of Representatives. (Courtesy of the Kansas City Call.)

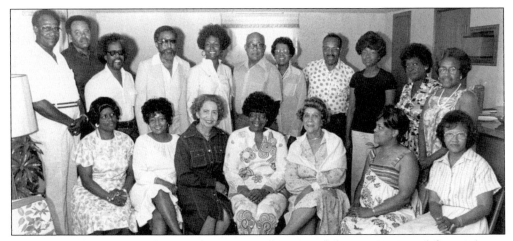

Seen here is the 1978 Freedom Fund Steering Committee of the NAACP. From left to right are (first row) Vernice Brinkley, Evelyn Welton, Irma Kelly, Dr. Julia Hill, Gussie Eckel, Dorothy Austin, and Melva Thomas; (second row) Dr. James S. Johnson, William Washington, John Myers, William Massye, Patricia Cowan Skagss, George Smith, Sybil Daniels, Chester Boyd, Mary Long, Lillian McKittrick, and Velma Woodson. In 1971, Dr. Julia Hill became the first female president of the Kansas City chapter of the NAACP. During her tenure as the NAACP branch president, the Kansas City chapter received the national Thalheimer Award "for contributing the most to the Association's mission for eight consecutive years." Dr. Julia Hill was also elected to the Kansas City School Board in 1984 and became president in 1990. She remained in that position until she retired in 1996. (Courtesy of the Kansas City Call.)

The Inter-City Dames was founded in the early 20th century and was one of the leading African American social clubs that included African American women from Kansas City, Kansas, and Kansas City, Missouri. Orchid Jordan is standing second from the left. Jordan, noted for her quiet manner, was a member of the Kansas City Urban League, the Kansas City Council on Crime Prevention, and Links Inc. (Courtesy of the Kansas City Call.)

NAACP members who celebrated 25 years of membership include Velma Woodson, Lillian McKittrick, Irma Kelly, and Lucile Bluford. A lifelong member of St. Augustine's Episcopal Church, Bluford belonged to a number of civic organizations, including Alpha Kappa Alpha Sorority Inc., Fellowship House, the Missouri Commission on Human Rights, the Niles Home for Children, and the Heart of America United Way. She was also a recipient of the NAACP's Distinguished Service Award. (Courtesy of the Kansas City Call.)

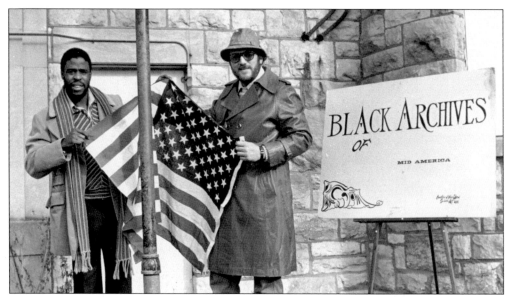

Horace Peterson III (left) founded the Black Archives of Mid-America in 1974. The archives were originally located in the Paseo YMCA building. Two years later, it relocated to Old Firehouse No. 11, at 2033 Vine Street. Some of the archives' most significant holdings include the collections of Chester A. Franklin and Ada Crogman Franklin, Minnie Crosthwaite, Wheatley-Provident Hospital, Chauncey Downs, and Alvin Ailey, as well as the Elijah Washington photograph collection, Aunt Lucy's slave cabin, and an original Ku Klux Klan robe and hood. Peterson died in a 1992 swimming accident. (Courtesy of the Kansas City Call.)

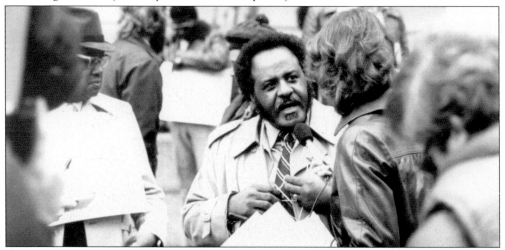

Rev. Wallace Hartsfield, pastor of Metropolitan Missionary Baptist Church at 2310 East Linwood Boulevard, is noted for his "fiery" civil rights activism. His notoriety began when he organized public accommodations protests in 1964 against segregated department stores in downtown Kansas City, including Kline's, Macy's, Peck's, and Emery Byrd Thayer. His devotionals "The Year of Jubilee: Symbol of Hope," "Safe in His Dwelling," and "The Hem of his Garment" are found in the 1997 *African American Devotional Bible*. Hartsfield has also served on a number of community and religious boards, including Kansas City's Jazz District Redevelopment Corporation, the Jackson County Diversity Task Force, and the Congress of National Black Churches, and as vice president-at-large of the National Baptist Convention of America. (Courtesy of the Kansas City Call.)

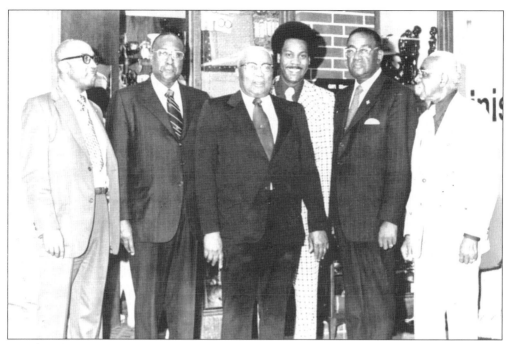

In 1968, African American Kansas Citians rioted in response to the assassination of Martin Luther King. Businesses at Thirty-first Street and Prospect Avenue, in particular, sustained damage because of their exploitative nature. Under the auspices of the Southern Christian Leadership Conference, Kansas City hosts one of the largest King birthday celebrations in the country. King's father, Rev. Martin Luther King Sr. (third from the left), is featured in this photograph during a visit to Kansas City. (Courtesy of the Kansas City Call.)

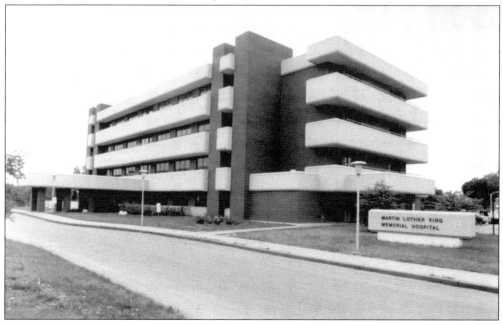

The Martin Luther King Memorial Hospital was named after the slain civil rights leader. (Courtesy of the Kansas City Call.)

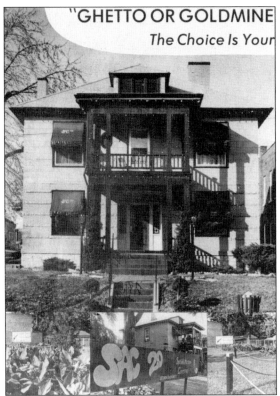

At Twenty-eighth Street and Brooklyn Avenue, a memorial salutes the work of slain civil rights and black power activist Bernard Powell. Powell founded the Social Action Committee of 20. Powell's famous mantra, "Ghetto or Goldmine, the Choice Is Yours," was a clarion call to improve African American neighborhoods, promote youth advocacy, and curb teen unemployment. (Courtesy of the Black Archives of Mid-America.)

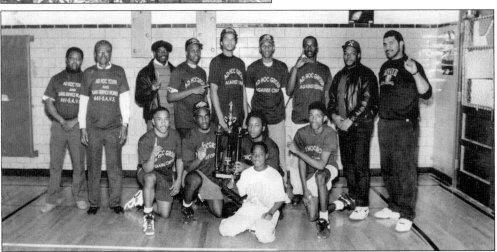

In 1977, Alvin Brooks, a former Kansas City police officer and the director of Kansas City's human relations department, founded the Ad Hoc Group Against Crime. The group was established to address crime and drug abuse in the African American community. Brooks, Lucile Bluford, Cliff Sargeon, and other community members were particularly concerned with a rash of unsolved murders of African American women. In this photograph, this Ad Hoc basketball team epitomizes the organization's commitment to building self-esteem, pride, and positive values through education, spirituality, prevention, and intervention. Ad Hoc garnered national attention under Pres. George Herbert Bush, who appointed Brooks to the President's Drug Advisory Council. (Courtesy of the Kansas City Call.)

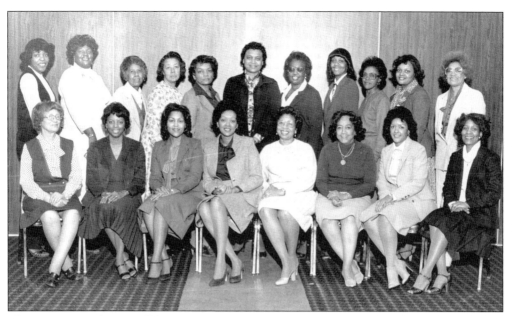

The Mu Omega chapter of the Alpha Kappa Alpha Sorority Inc. sponsored the annual Ebony Fashion Fair. Members of the 1980 planning committee include, from left to right, (first row) Lucile Berry, Evelyn Young-Ponder, Melody Bailey, Barbara Luck, Helen Boswell, Maudell Perkins, Cherry Mallory, and Gwendolyn Swoop; (second row) Emma Henderson, Marjean Watson, Lillian Orme, Mary Washington, Patricia Caruthers, Wilma Armstrong, Annette Ashley, Maxine Myers, Jessie Kirksey, and Charlotte Goodseal. (Courtesy of the Kansas City Call.)

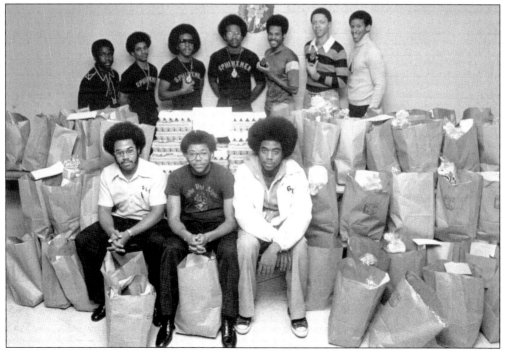

In this photograph, the Delta Rho chapter of Alpha Phi Alpha Fraternity Inc. collects canned goods and nonperishable foods. (Courtesy of the Kansas City Call.)

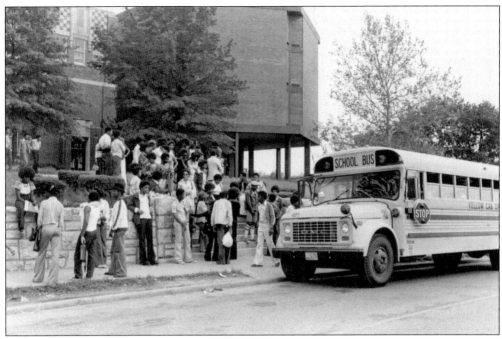

Lincoln High School, or the "Castle on the Hill," was opened in 1936 at Twenty-first Street and Woodland Avenue. Previously the school had operated at Nineteenth Street and Tracy Avenue. (Courtesy of the Kansas City Call.)

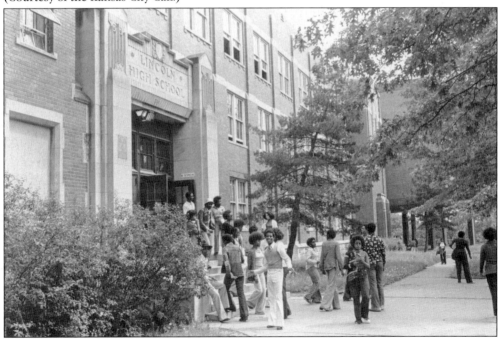

Lincoln High School was noted for its excellent teachers, including the artist Aaron Douglass; Trussie Smothers, an English teacher who inspired journalist Lucile Bluford; and Dr. Girard T. Bryant, who had taught history at Lincoln before he became the first African American to serve on the Kansas City police board. (Courtesy of the Kansas City Call.)

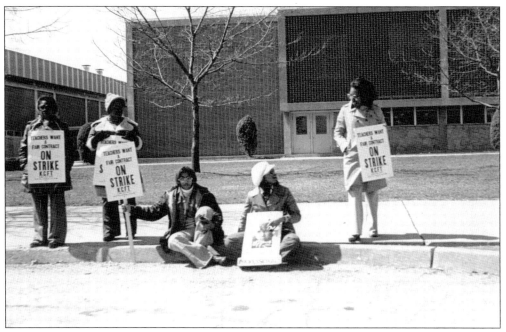

Lincoln High School teachers are on strike for better wages, benefits, and working conditions. Salary inequities had always plagued African American teachers even before the 1940s; the Kansas City chapter of the NAACP had sought redress of this issue. (Courtesy of the Kansas City Call.)

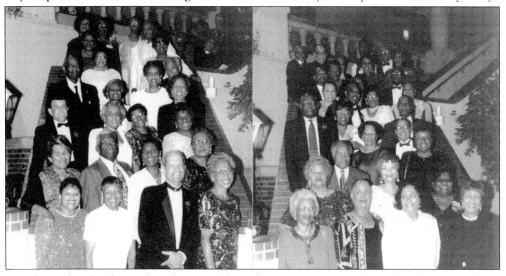

Lincoln High School was the educational base for Kansas City's "talented tenth." Some of the school's most renowned graduates are Dr. Clarence A. Bacote; 1928 class valedictorian Lucile Bluford; David Crosthwaite Jr.; jazz saxophonist Charlie Parker; James Scott; and Dr. Hazel Browne Williams, the first African American faculty member at the University of Missouri–Kansas City. Lincoln alumni are noted for their school spirit. Alumni, in particular, were instrumental in retaining this institution of excellence in the African American community despite an arduous school desegregation process. The school has been renamed Lincoln College Preparatory Academy and offers an international baccalaureate. This photograph is the 50th reunion of the class of 1947. (Courtesy of Ida M. Hughes.)

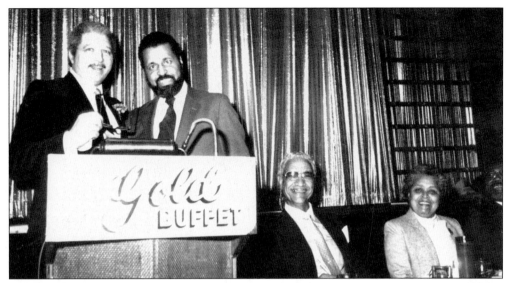

Marcheita and Jack Bush listen to a presentation from Ollie Gates (left) and Phil Curls. Under the administration of Emanuel Cleaver, Gates served on the Kansas City board of parks and recreation. He particularly focused on the improvement and beautification of the neglected inner-city African American neighborhoods. Former state legislator and senator Phil Curls served two terms as president of Freedom Inc. from 1979 until 1985 and then again from 1988 until 1992. The Bushes are past supporters of the Boys and Girls Clubs of Greater Kansas City. Jack Bush coached 52 seasons before retiring from Central High School in 2002. (Courtesy of William and Annette Curtis.)

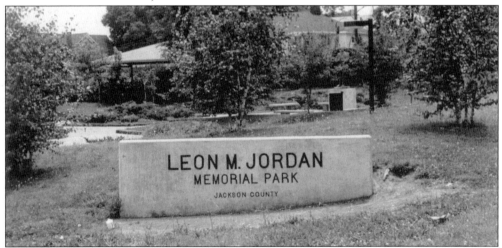

Leon M. Jordan Memorial Park at Thirty-first Street and Benton Boulevard honors the slain Kansas City civil rights leader. In 1936, Jordan joined the Kansas City Police Department and served the community as a police officer for 16 years. His career also had international dimensions when he spent eight years in Liberia organizing its police force. Jordan owned and operated the Green Duck tavern and a liquor store, both located next door to what became the Freedom Inc. headquarters. Jordan was elected to the Missouri House of Representatives in 1964. A member of the Elks Lodge, Jordan was also a member of the NAACP and St. Augustine's Episcopal Church. A statue of Jordan in the park is a quiet reminder that this civil rights murder from 1970 remains unsolved. (Courtesy of the Kansas City Call.)

In this photograph, NAACP members meet to plan chapter activities. During the 1980s, the NAACP focused on voter registration drives. In 1984, Kansas City hosted the National NAACP Diamond Jubilee Convention. They also developed Operation Hot-Line, a telephone tutoring service for high school students. (Courtesy of the Kansas City Call.)

These campaigners support Alan Wheat for the United States Congress. (Courtesy of the Kansas City Call.)

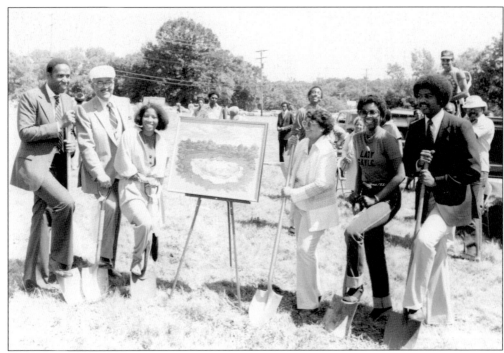

Bruce R. Watkins, second from the left in his last public appearance, helps to break ground on the Spirit of Freedom Fountain. He is joined by community supporters, including Gertrude Keith (third from the right) and Alan Wheat (far right). (Courtesy of the Kansas City Call.)

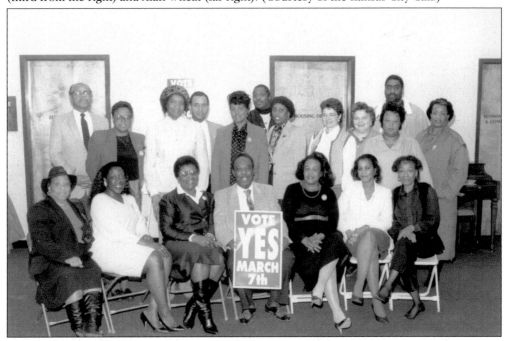

Rev. Earl Abel (center with sign) is joined in this photograph by a number of community supporters, including Byron Buford, Isolene Clark, Carol Coe, and Eddie Penrice. (Courtesy of the Kansas City Call.)

This young student in front of Blenheim Elementary School is symbolic of the wellspring of talent in the Kansas City, Missouri, School District. Yet decades of desegregation orders have not brought about equality. The NAACP, in particular, issued a "Declaration of Educational Emergency" because of the poor conditions of schools and the general well-being of African Americans students.

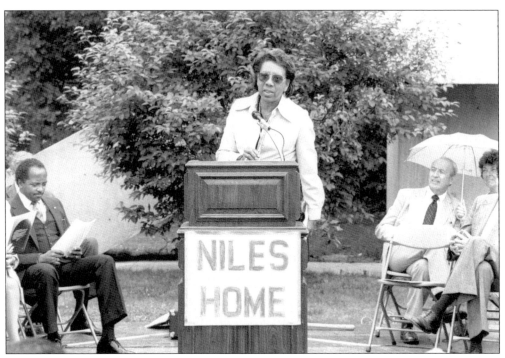

This photograph shows tennis legend Althea Gibson speaking at a fund-raiser for the Niles Home for Children. (Courtesy of the Kansas City Call.)

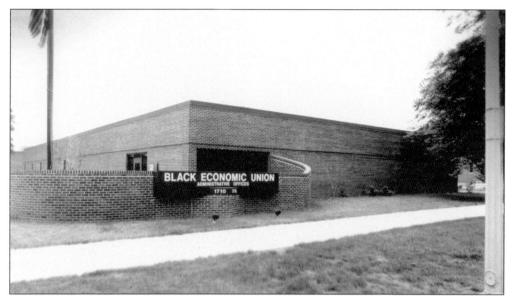

The Black Economic Union (BEU) of Greater Kansas City is the oldest community development corporation in the metropolitan area. Established in 1968, the BEU maintains an impressive record in housing and urban development. The BEU has also been active in new home development in the Historic Eighteenth and Vine District. The BEU is a kindred soul to Leona Pouncey Thurman, Kansas City's first African American female attorney. Thurman's work was a forerunner to the BEU in that she also owned, developed, and helped to preserve property around the Eighteen and Vine Streets district. (Courtesy of the Living History Collection, Joe Mattox.)

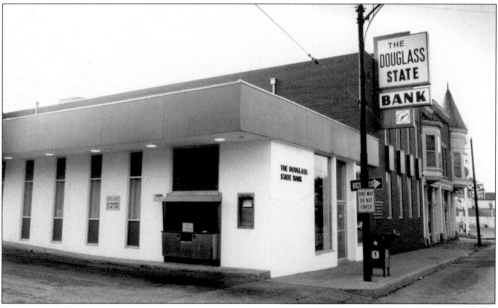

Henry W. Sewing founded Douglass State Bank in 1947. Named after the abolitionist Frederick Douglass, the bank operates on both sides of the state line. Past members of the board of directors have included Bishop John Andrew Gregg, attorney Cordell Meeks, Palace Cab company owner Isadore Gross, Lincoln University president Dr. Sherman D. Scruggs, and Bethel African Methodist Episcopal Church trustee Wesley Elders. (Courtesy of the Living History Collection, Joe Mattox.)

Since 1968, Leon's United Supers Grocery Store (now Leon's Thriftway Supermarket) at 4400 East Thirty-ninth Street has been the only African American owned and operated grocery store in Kansas City. Leon and Willosia Stapleton are members of the Independent Grocers Association. (Courtesy of the Living History Collection, Joe Mattox.)

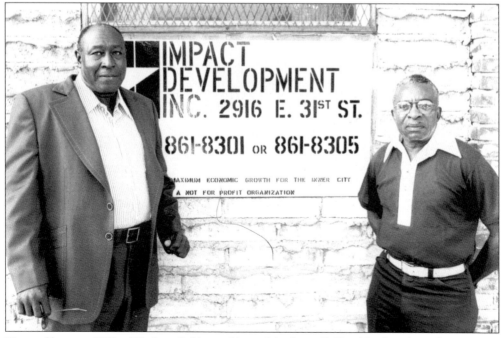

Pictured here are Willard Shelton (left), president of the Santa Fe Neighborhoods, and Larry Lowe of the Santa Fe Area Action Coalition, which supports inner-city urban development. (Courtesy of the Kansas City Call.)

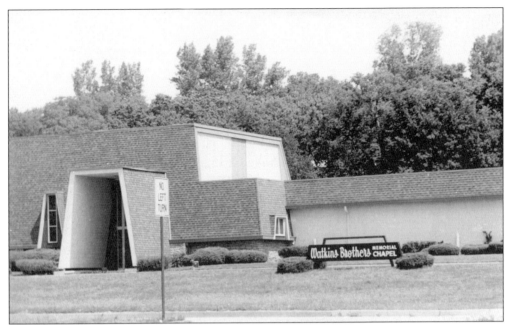

The Watkins Brothers Memorial Chapel at 4000 Cleaver II Boulevard was originally established in 1909 by brothers Theron B. and John T. Watkins at 1729 Lydia Avenue. "T. B." Watkins was a major supporter of the 1913 Paseo YMCA campaign, Paseo Baptist Church, and the Gateway Athletic Club. He was also a member of several fraternal organizations, including the Odd Fellows, the Elks, and the Beau Brummel Club. (Courtesy of the Living History Collection, Joe Mattox.)

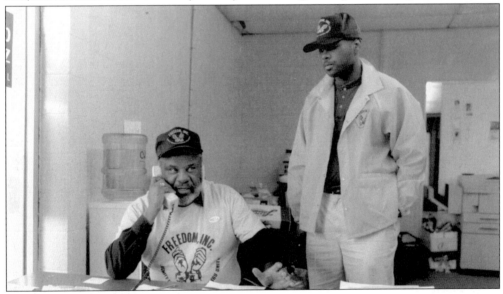

Freedom Inc. perfected direct action methods like door-to-door canvassing for registration, organizing public forums, and even driving voters to the polls on Election Day. Freedom Inc. volunteers Aasim Bahyadeen, pictured here on the telephone, and Jason Hardiman, a driver, work behind the scenes to get voters to the polls for the March 1999 elections. In 2006, Bahyadeen (a member of the Ad Hoc Group Against Crime Steering Committee) ran for elected office to represent the 37th District in the Missouri House of Representatives. (Courtesy of the Kansas City Call.)

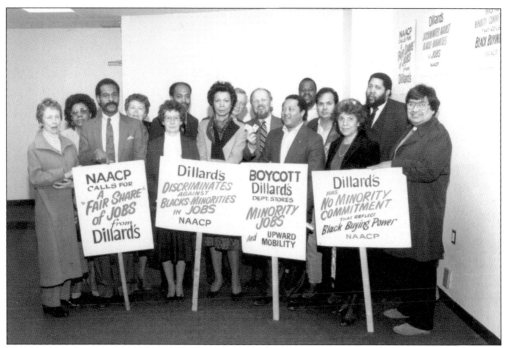

In the 1980s, the NAACP protested discrimination and called for boycotts of Dillard's department stores. (Courtesy of the Kansas City Call)

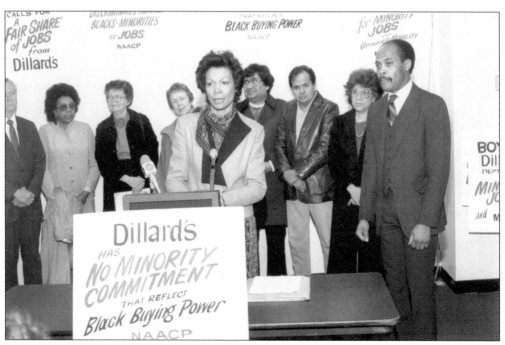

Dr. Zelema Davis, NAACP president and Penn Valley Community College president, presents the demonstrators' position on issues of equity and empowerment. Davis earned her doctorate at the University of Kansas. (Courtesy of the Kansas City Call.)

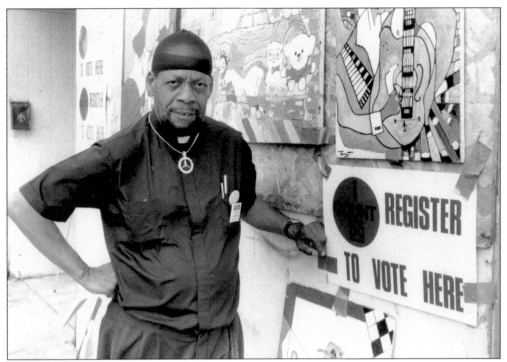

Tom Neely, a former vice president and Freedom Inc. board member, works for voter participation. (Courtesy of the Kansas City Call.)

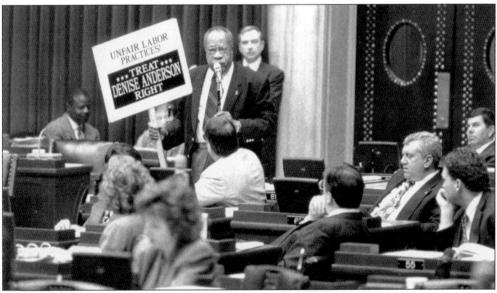

Rep. Fletcher Daniels waves a sign proclaiming "Treat Denise Anderson Right." Anderson received widespread support (including an NAACP-sponsored rally) in her discrimination suit against General Motors. Daniels, a noted legislator, served as the speaker pro tem of the Missouri House of Representatives in 1996. The retired postal employee was active in the Legislative Black Caucus, the NAACP, and the Urban League. Daniels also served on the Kansas City School Board from 1974 until 1986. (Courtesy of the Kansas City Call.)

In 1949, Florida native Mamie Curie Hughes completed her bachelor of arts degree at Fisk University. After a short stint in Mississippi, she settled in Kansas City where her social activism and quest for social justice is known today. Hughes was an educator, a Jackson County legislator, a past president and CEO of the BEU, and an ombudsman of Bruce R. Watkins Drive. A cofounder of Freedom Inc. with her husband, Leonard, Hughes currently chairs the board of the Samuel U. Rogers Health Clinic. A recipient of the 2005 YWCA Heart of Gold Award, Hughes is also working on a history of the Lake Placid, Missouri, resort. Lake Placid was established by Dr. Perry C. Turner, superintendent of General Hospital No. 2 from 1933 to 1945, to provide a recreational sanctuary for African Americans in the Jim Crow era.

Mamie Curie Hughes's son Judge Leonard Hughes III (left), the youngest judge ever elected in Jackson County, is pictured with attorney Clinton Adams Jr. conversing on legal issues. (Courtesy of the Kansas City Call.)

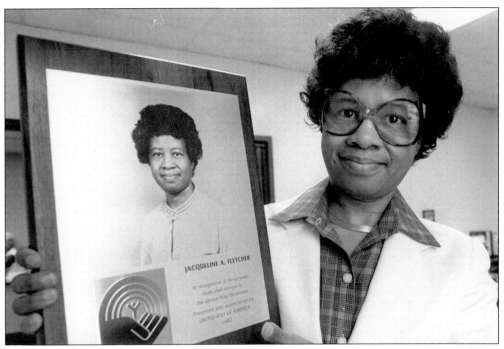

Continuing the traditions of community activism, Jacqueline Fletcher displays the plaque for 30 years of service that was given by the United Way of America in 1980. (Courtesy of the Kansas City Call.)

Kansas City's civil rights matriarch Lucile Bluford is seen here hugging her nephew, astronaut Guion Bluford, after safely landing from a NASA mission. He was the first African American in space. The University of Missouri honored Lucile Bluford with an Honor Medal for Distinguished Service in Journalism in 1984 and an honorary doctorate in 1988. Both awards were in recognition of her journalism career, civil rights achievement, and her effort to desegregate the University of Missouri in the 1930s and 1940s. A branch of the Kansas City Public Library System was also dedicated in her name at Thirty-first Street and Prospect Avenue in 1988. Bluford was awarded the Kansas Citian of the Year from the Greater Kansas City Chamber of Commerce in 2002. (Courtesy of William and Annette Curtis.)

Six

A New Millennium

Lucile Bluford is shown at the *Kansas City Call* office with students from Marlborough Elementary School. Congressman Emanuel Cleaver once remarked that "Miss Bluford will go down in history as one of the most unparalleled African-American personalities in our city. At one time, we had no African-American council members or representatives. All we had was Miss Bluford." (Courtesy of the Kansas City Call.)

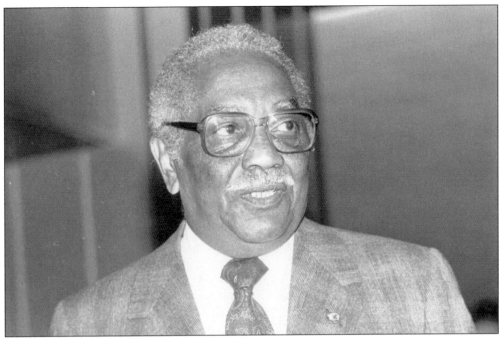

Herman A. Johnson was a former NAACP Kansas City branch and state legislator. Since 1987, the largest privately endowed scholarship to support African American students has been offered at the University of Missouri–Kansas City and was named in his honor. (Courtesy of the Kansas City Call.)

Dorothy Hodge Johnson was a civic leader, activist, and former reporter at the *Kansas City Call*. From 1944 to 1951, she served as public relations secretary for the Urban League of Kansas City. Johnson served on the boards of leading civic organizations in Kansas City, including the YWCA, the City Committee and Council on Human Relations, and the City Children's Committee. (Courtesy of the Kansas City Call.)

Alan Dupree Wheat was elected to the United States Congress in 1982. He was the first African American elected from the mainly white Fifth District. He did not seek reelection in 1994 but instead ran for the United States Senate, where he was unsuccessful. (Courtesy of the Kansas City Call.)

Alvin Brooks was the first African American to serve on the board of regents at the University of Central Missouri in 1974. He is joined by his wife, Carol (left), as they greet E. Lenita Johnson, the first African American president of the University of Central Missouri's board in 2003. Johnson is the communications and marketing director for the Injury Free Coalition for Kids. (Courtesy of Dr. Carrie Dunson.)

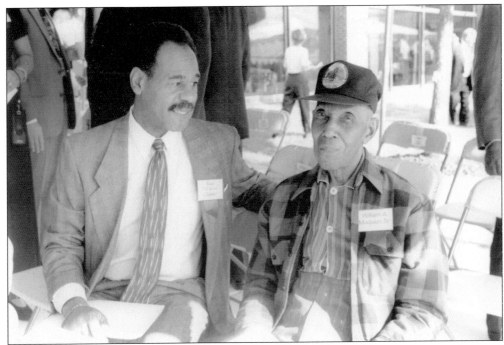

Emanuel Cleaver takes time to chat with William A. Madison Sr., who was 103 and attended the grand opening of the Swope Park Community Health Center. (Courtesy of the Kansas City Call.)

Bird Lives is a 17-foot bronze reflection of Charlie Parker designed by sculptor Robert Graham. It is the focal point at Charlie Parker Memorial Plaza in the Historic Eighteenth and Vine District. (Courtesy of the Kansas City Call.)

In this photograph, community activist and attorney Carol Coe promotes the interests of the Black Archives of Mid-America. (Courtesy of the Black Archives of Mid-America.)

The Black Archives
Of Mid-America, Inc.
2033 Vine Street
Kansas City, Missouri 64108
Telephone: 483-1300

February 1, 1984

Dear Fellow Citizens:

Each year the Black Archives of Mid-America, Inc. sponsors several exhibits throughout the State of Missouri and Kansas highlighting contributions and history portraying the life and History of Afro-Americans.

The exhibit that is currently showing depicts a political, social and general commentary on Black Americans inkansas City and nationally. This exhibit is unique because of the medium used to communicate ideas and impressions through the eyes and talents of an editorial cartoonist.

Lee Judge, the artist is an employee of the Kansas City Times and is nationally known and recognized as one of the most progressive political cartoonist in America. His work is entertaining, thought provoking and often controversial. His work becomes significant to us because of the capsulization of attitudes and events in our community and nation.

The Black Archives of Mid-America, Inc. is pleased to exhibit the works of Lee Judge as a part of our Tenth Anniversary celebration and our annual Black History exhibits.

With Warm Regards,

Carol Coe

Carol A. Coe, Esq.
Chairman of the Board

A third-generation activist, Rep. Leonard "Jonas" Hughes was elected to the Missouri General Assembly House of Representatives in 2004. He is the grandson of Leonard and Mamie Hughes. Representative Hughes sits on the rules, appropriations, and financial institutions committees. (Courtesy of Leonard Hughes IV.)

Georgia Buchanan is the president and CEO of All Pro Construction Inc. She is also the widow of former football legend Buck Buchanan and established the Buck Buchanan Fund at the Greater Kansas City Community Foundation and Affiliated Trusts. Her business acumen is widely recognized, and in 2005, Georgia Buchanan was appointed to the Jackson County Sports Complex Authority. (Courtesy of the Kansas City Call.)

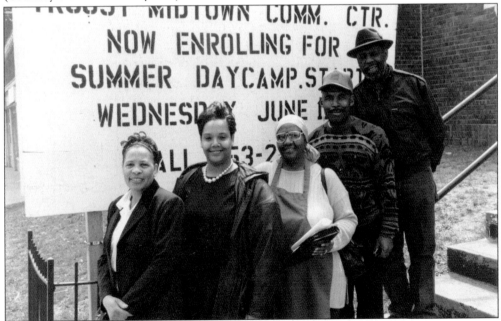

In this photograph, African American small-business owners meet at the Troost-Midtown Community Center. They include, from left to right, Doris F. Lyman, Papa Lews BBQ and Soul Food; Sydnei Dunn, Wings N' Things; Delores Kalimullah, Tariqs Deli and Unique Pies; Charles Isaac, Adam's Rib BBQ; and Jim Reed, Jim's Diner. (Courtesy of the Kansas City Call.)

The Gregg Community Center and Arrington Klice Fitness Center is located at 1600 John "Buck" O'Neil Way. The center is named for Bishop John Andrew Gregg, an ardent supporter of the African American YMCA movement and the author of a powerful exposé on the Tulsa race riots. Arrington "Bubbles" Klice dedicated his life to coaching young men and training boxers in the inner city. (Courtesy of the Kansas City Call.)

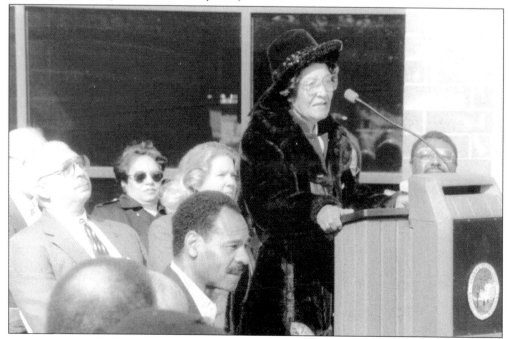

In this photograph, Gertrude Keith speaks at the dedication ceremony for the Gregg Klice Community Center. Ollie Gates (left) and Emanuel Cleaver (center) are seated in the audience. (Courtesy of the Kansas City Call.)

Bobbye Jean Fuller receives the first Child Care Champion award from the Francis Child Development Institute. Fuller is the director of the St. Mark's United Inner City Services Child Care. E. Paul Williams, former president of Penn Valley Community College, is shown congratulating Fuller. (Courtesy of the Kansas City Call.)

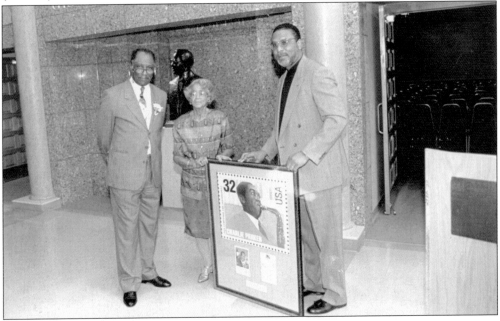

This photograph shows, from left to right, Sonny Gibson, Gertrude Keith, and Ormer Rogers at the Bruce R. Watkins Cultural Heritage Center unveiling the new Charlie Parker stamp. Gibson is a respected local historian who has published on the Historic Eighteenth and Vine District. Rogers retired in 2006 from the United States Postal Service. (Courtesy of the Kansas City Call.)

Pictured here on the right is the former owner and publisher of the *Kansas City Call*, Ruben Benton. (Courtesy of the Kansas City Call.)

This photograph showcases the Eighteenth and Vine Streets planning commission at the corner of Eighteenth Street and the Paseo Boulevard. (Courtesy of the Kansas City Call.)

Robert Gillis, a retired codes enforcement officer for the City of Kansas City, served six years as vice president and president of Local 500 of the American Federation of State, County, and Municipal Employees. Under his leadership, Kansas City's largest public union significantly increased its membership, elected pro-labor candidates to the city council and state legislature, negotiated a living wage with city officials, and fought privatization of the water department. (Courtesy of the American Federation of State, County, and Municipal Employees.)

M. Jenise Comer, a former deputy director and therapist at the Niles Home for Children, was the first African American woman to be promoted to the rank of full professor at the University of Central Missouri in 2002. She has served three terms as a Missouri delegate to the National Association of Social Workers. Both Gov. Mel Carnahan and Matt Blunt appointed Comer to the State Committee for Social Workers and the Social Work Licensing Board. In 2005, she was elected to chair the committee. (Courtesy of the University of Central Missouri.)

The Honorable Sharon Sanders Brooks was elected to the Missouri General Assembly House of Representatives in 2000. Representative Sanders Brooks is a historical consultant. Formerly she was a civil rights investigator, investigating employment and fair housing discrimination complaints in Kansas City. She was also a journalist in Kansas City. (Courtesy of Sharon Sanders Brooks.)

Even in the year 2006, some Missourians were still fighting the Civil War by lobbying lawmakers, including the governor, to allow the Confederate battle flag to be hoisted in public view at state historical sites. Award-winning filmmaker Kevin Willmott captures the irony in his mockumentary *CSA: The Confederate States of America*—what if the Confederates had won the Civil War? (Courtesy of Kevin Willmott.)

Kansas City's beloved ambassador of goodwill Buck O'Neil greets June Hollowell Ross at the American Jazz Museum. Ross is a motivational speaker, veteran educator, and the assistant director of Youth Services at Paseo Baptist Church. (Author's collection.)

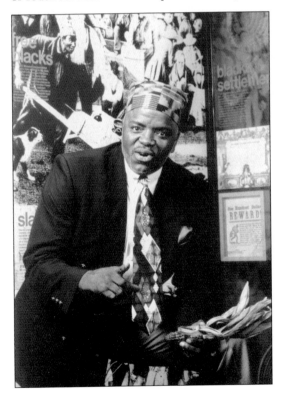

Brother John, Geneva Price, Tracy Milsap, and Milton Gray are among several African American griots who promote cultural traditions in Kansas City. In this photograph, storyteller Milton Gray shares a Kwanzaa story with his audience. (Courtesy of the Kansas City Call.)

As early as 1896, the first art club, Alpha Art Club, was founded in neighboring Kansas City, Kansas. Its artwork included Battenburg embroidery, Roman cutwork, and china painting, as well as crocheting and knitting. Nedra Barnes, a nationally acclaimed quilt artist, continues those traditions as part of The Light in the Other Room, a collaborative of African American artists in the Kansas City metropolitan area founded by Lonnie Powell. (Courtesy of Nedra Barnes.)

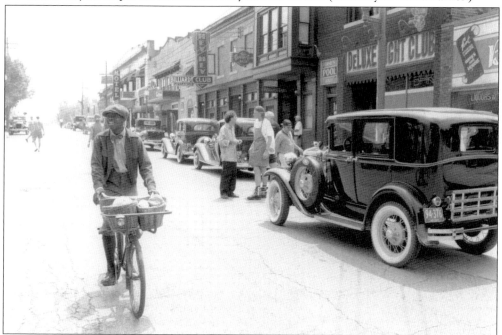

In 1996, Robert Altman, a Kansas City native and filmmaker, released *Kansas City*. Set in the 1930s, the movie starred Harry Belafonte and was filmed on location in the Historic Eighteenth and Vine District. (Courtesy of the Kansas City Call.)

Crew members for *Kansas City* develop the set using authentic street scenes from the jazz area. (Courtesy of the Kansas City Call.)

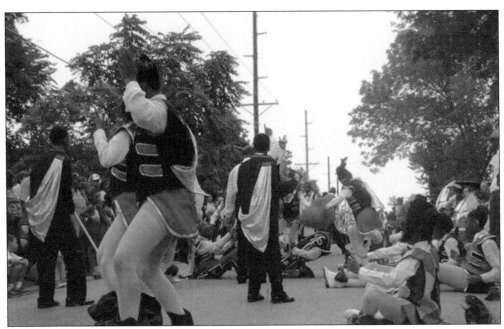

Founded in 1969 by educator Willie Arthur Smith, the Kansas City Marching Cobras are internationally known with over 300 first-place awards. In this photograph, students performed in honor of ragtime legend John William "Blind" Boone at an annual festival in nearby Warrensburg. (Courtesy of Steven Grandfield and Sandra Irle.)

Many Kansas Citians are active supporters of the Buffalo Soldier's Monument at nearby Fort Leavenworth, Kansas. The monument was dedicated in honor of the segregated 9th and 10th Calvary units that settled the western frontier. (Courtesy of the Kansas City Call.)

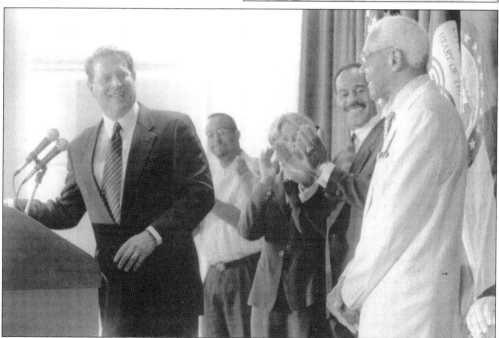

Former vice president Al Gore honors Buck O'Neil on a Kansas City visit. In February 2006, the National Baseball Hall of Fame at Cooperstown failed to induct the legendary O'Neil by vote. O'Neil was posthumously awarded the Presidential Medal of Freedom, the nation's highest civilian honor, on December 15, 2006.

Civil rights activist Rev. Fuzzy Thompson, seen on the left, joins Mildred Carter and Michael Carter (right) of KPRS 103.3 FM. Founded in 1950 by Andrew Carter, KPRS is the oldest black-owned radio station in the United States. (Courtesy of the Kansas City Call.)

Attucks School is located just one block south of Woodland Avenue and Eighteenth Street and became the premier African American school in Kansas City during the first half of the 20th century. Community activist Mamie Hughes taught at Attucks School, and Charlie Parker attended the school. Yet for all its historical significance and beautiful architecture, the building sits vacant as the redevelopers of the Historic Eighteenth and Vine District have overlooked its possibilities for revitalization and preservation. (Courtesy of the Kansas City Call.)